THE WRATH OF THE GODS

THE WRATH OF THE GODS

MASTERPIECES BY RUBENS, MICHELANGELO, AND TITIAN

CHRISTOPHER D. M. ATKINS

PHILADELPHIA MUSEUM OF ART

in association with YALE UNIVERSITY PRESS

NEW HAVEN AND LONDON

Published on the occasion of the exhibition
The Wrath of the Gods: Masterpieces by Rubens, Michelangelo, and Titian, Philadelphia Museum of Art, September 12–December 6, 2015.

The exhibition was made possible by The Pew Charitable Trusts, the Kowitz Family Foundation, the Samuel H. Kress Foundation, and The Robert Montgomery Scott Endowment for Exhibitions. Additional generous support was provided by Anthony L. Schaeffer, Maude de Schauensee, James and Susan Pagliaro, Lisa D. Kabnick and John McFadden, Paul K. Kania, and Agnes M. Mulroney, and by an indemnity from the Federal Council on the Arts and the Humanities.

This publication was supported by The Andrew W. Mellon Fund for Scholarly Publications at the Philadelphia Museum of Art.

Credits as of June 24, 2015

Produced by the Publishing Department
Philadelphia Museum of Art
Sherry Babbitt
The William T. Ranney Director of Publishing
2525 Pennsylvania Avenue
Philadelphia, PA 19130-2440 USA
www.philamuseum.org

Edited by David Updike
Production by Richard Bonk
Designed by Bessas & Ackerman, Branford, CT
Color separations, printing, and binding by Conti Tipocolor S.p.A., Florence, Italy

Published in association with
Yale University Press
302 Temple Street
P.O. Box 209040
New Haven, CT 06520-9040 USA
www.yalebooks.com/art

Library of Congress Control Number: 2015939332

ISBN 978-0-87633-266-5 (PMA)
ISBN 978-0-300-21524-3 (Yale)

FRONT AND BACK COVER: Peter Paul Rubens and Frans Snyders, *Prometheus Bound*, begun c. 1611–12, completed by 1618 (details of plate 1)
PAGE 1: Frans Snyders, *Study for Prometheus*, 1612 (detail of plate 18)
OPPOSITE: Hendrick Goltzius after Cornelis Cornelisz. van Haarlem, *Phaeton*, 1588 (detail of plate 12)
PAGE 40: Peter Paul Rubens, *Raising of the Cross*, 1610–11 (detail of fig. 19)
PAGE 58: Dirck Volckertsz. Coornhert after Maarten van Heemskerck, *The Dangers of Human Ambition*, 1549 (detail of fig. 28)
PAGE 71: Rembrandt Harmensz. van Rijn, *The Blinding of Samson*, 1636 (detail of fig. 40)
PAGE 87: Paul Manship, *Prometheus*, 1934 (detail of fig. 49)

LENDERS TO THE EXHIBITION

The British Museum, London

Museo Nacional del Prado, Madrid

Rose-Marie and Eijk van Otterloo Collection

Pennsylvania Academy of the Fine Arts, Philadelphia

The Royal Collection / Her Majesty Queen Elizabeth II

Wallraf-Richartz Museum and Fondation Corboud, Cologne

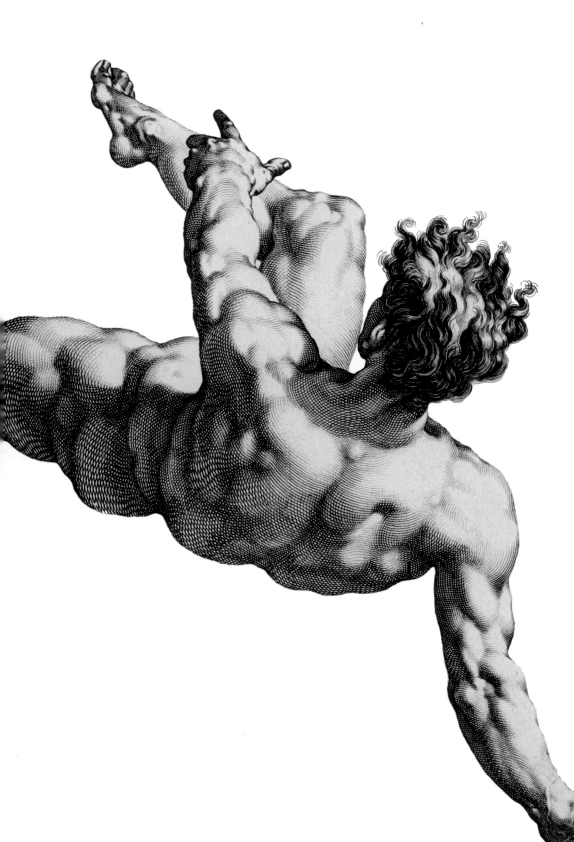

CONTENTS

FOREWORD

At a time when the museum-going public has become accustomed to exhibitions that are ambitious and occasionally exhausting in scale, it is both a luxury and, one might argue, a necessity to present a show that focuses on a single work of art and that richly illuminates its history, its meaning, and the context in which it was created.

Fortunately, the collection of the Philadelphia Museum of Art is full of masterpieces that reward such an approach. Among them is the large canvas, nearly eight feet in height, entitled *Prometheus Bound*, by the great Flemish artist Peter Paul Rubens. Few treatments of the story of the eternal punishment inflicted by Zeus on the Titan who defied him by stealing fire from Olympus are as compelling as Rubens's dramatic depiction of Prometheus writhing in torment as an eagle plucks out his liver. As gruesome as this scene may be, such is the power of the artist's conception that we cannot avert our eyes. Rather, we are drawn to it by the masterful rendering of the monumental figure of Prometheus, chained to a rocky outcropping in the foreground, and by the great eagle—painted by Rubens's contemporary Frans Snyders—that grips him in its talons.

As Christopher D. M. Atkins, our Agnes and Jack Mulroney Associate Curator of European Painting and Sculpture before 1900 and the curator of this exhibition, observes in his essay, *Prometheus Bound* mattered deeply to Rubens. It is a tour de force of figural painting, with the physical and emotional suffering endured by the Titan registered in his clenched fists, his splayed toes, and every contortion of his body.

This painting also stands at the center of a complex story about artistic influence and the transmission of ideas across Europe in the early seventeenth century, when the aesthetic of the Baroque was being formed by the dynamic vision of artists such as Rubens. In this case, the lineage of *Prometheus Bound* can be traced to works by Titian and Michelangelo that Rubens saw and admired, as well as to treatments of this or similar subjects by earlier northern artists such as Michiel Coxcie and Hendrick Goltzius. In turn, Rubens's powerful—and powerfully imagined—rendering of the punishment of Prometheus had a profound impact on the many artists who followed in his footsteps.

This story is told in compelling detail by Dr. Atkins, who conceived this project and has overseen every aspect of the development of this catalogue and the exhibition it accompanies with great skill and a collaborative spirit. We are grateful to Chris for the time and energy he has devoted both to illuminating the history and meaning of *Prometheus Bound* and to sharing the fruits of this work with public audiences.

In the acknowledgments that follow he has thanked the many individuals who helped us with the preparation of the exhibition and catalogue. I will simply add here that we are deeply grateful for their assistance, without which his vision could not have been as richly realized as it has come to be. This applies to colleagues in other institutions as well as to our own staff, all of whom gladly embraced this project—responding, no doubt, to the passion that Dr. Atkins has for this subject—and helped in many different ways.

Special mention should be made of the generosity of the institutions that agreed to lend precious works of art from their collections—most notably the Royal Collection housed in Windsor Castle just outside of London and the Museo Nacional del Prado in Madrid—to the exhibition to help us place *Prometheus Bound* in context, and to the many donors without whose financial support we could not have undertaken this project.

What unites these collaborative efforts is a commitment to the mission of the Philadelphia Museum of Art to bring our collection to life for audiences in new and engaging ways, and a desire to share our passion for the great works in our care. Few are more significant—or of greater interest—than the masterpiece by Rubens that is the subject of this catalogue and the centerpiece of the exhibition it accompanies.

TIMOTHY RUB
The George D. Widener Director
and Chief Executive Officer

ACKNOWLEDGMENTS

Exhibitions and publications are the products of deep and sustained collaboration. It is a pleasure to thank all who have contributed to this catalogue and the exhibition it accompanies.

I thank Agnes and Jack Mulroney for endowing my position at the Museum, and Agnes for further supporting the present exhibition. My thanks also go to Tony Schaeffer, who offered crucial assistance in the initial phases of the project; it has been great fun sharing its growth and development with him. I am also deeply grateful to David Kowitz and the Kowitz Family Foundation and the Samuel H. Kress Foundation, whose generosity enabled the exhibition to come to fruition. Maude de Schauensee, James and Susan Pagliaro, Lisa D. Kabnick and John McFadden, and Paul K. Kania also provided much-appreciated support. I am immensely indebted to them all.

The project took inspiration from Miguel Falomir's magisterial 2014 exhibition *Las Furias* at the Museo Nacional del Prado. The initial kernel of an idea began with the possibility of borrowing Titian's great *Tityus* to hang alongside Rubens's *Prometheus Bound* in Philadelphia, as it had in the exhibition in Madrid. Later, Michiel Coxcie's *Death of Abel* not only joined the conversation, but was restored to its former glory in time for the installation in Philadelphia. I thank all those at the Prado who enabled these signature loans, including Miguel Zugaza, Alejandro Vergara, and Teresa Posada Kubissa. The generosity of the Prado has been matched by the other lenders. This show would not have been possible without Martin Clayton and Lauren Porter at the Royal Collection Trust; Neil MacGregor and An Van Camp at the British Museum, London; Marcus Dekiert and Anja Sevcik at the Wallraf-Richartz Museum and Fondation Corboud, Cologne; Rose-Marie and Eijk van Otterloo and, on their behalf, Jean Woodward; and David Brigham, Jeffrey Carr, and Brian Boutwell at the Pennsylvania Academy of the Fine Arts, Philadelphia.

The following colleagues near and far offered all manner of help at all the most opportune moments: Ronni Baer, Katrin Bellinger, Blaise Ducos, John Gash, Martin Graessle, David Jaffe, Anne Lowenthal, Otto Naumann, Gregory Rubinstein, Tico Seifert, Anna Tummers, Aidan Weston-Lewis, and Jeremy Wood.

At the Philadelphia Museum of Art, I benefit from working with a world-class team of colleagues, each of whom gave nothing but the fullest support and encouragement. Our director, Timothy Rub, never flagged in his enthusiasm for the show and offered the sage advice to keep the project tightly focused. Alice Beamesderfer, The Pappas-Sarbanes Deputy Director for Collections and Programs, stepped in at all the appropriate junctures to make sure that all progressed smoothly. Joseph Rishel, The Gisela and Dennis Alter Senior Curator of European Painting before 1900, and Senior Curator of the John G. Johnson Collection and the Rodin Museum, encouraged *Wrath of the Gods* from the roughest concept and provided me the freedom to see how it might take shape. Other colleagues in the Department of European Painting encouraged and facilitated the exhibition, including Carl Strehlke, Curator Emeritus, John G. Johnson Collection; Jennifer Thompson, The Gloria and Jack Drosdick Associate Curator of European Painting and Sculpture before 1900 and the Rodin Museum; Ashley McKeown; and Emily Rice. Curators from other departments gamely contributed objects and ideas, including Innis Howe Shoemaker, The Audrey and William H. Helfand Senior Curator of Prints, Drawings, and Photographs; John Ittmann, The Kathy and Ted Fernberger Curator of Prints; Anna Juliar, Margaret R. Mainwaring Curatorial Fellow in Prints, Drawings, and Photographs; and Jack Hinton, Associate Curator of European Decorative Arts and Sculpture. Of particular note, Shelley Langdale, Associate Curator of Prints and Drawings, provided all manner of assistance, ensuring that the Museum's choice collection of prints was well integrated into the exhibition. Suzanne F. Wells, Director of Special Exhibitions Planning, with the assistance of Cassandra DiCarlo, oversaw the planning of the show, guiding me through the processes with aplomb.

Wynne Kettell and Irene Taurins handled all registration issues with impeccable professionalism. Scott Homolka and Rebecca Pollak superbly conserved several of the Museum's works on paper for the exhibition. Also in conservation, valuable expertise was lent by Mark S. Tucker, The Aronson Senior Conservator of Paintings and Vice Chair of Conservation; Nancy Ash, The Charles K. Williams, II, Senior Conservator of Works of Art on Paper; Sara Reiter, The Penny and Bob Fox Senior Conservator of Costume and Textiles; Teresa Lignelli, The Joan and John Thalheimer Conservator of Paintings; Sarah Gowen, Mellon Fellow in Paintings Conservation; and Christopher Ferguson, Conservation Framer. The entire staff of the library, especially Evan Towle and Rick Sieber, helped me fill all manner of lacunae. Without the tireless efforts of my friends in Development—David Blackman, Jane Allsopp, Mimi Stein, Danielle Smereczynski, Tracy Carter, Lisa Brown, Ann Kirschner, Nico Hartzell, and Tricia Handza—we would not have been able to actualize any of the ideas we had. I am forever in their debt.

The Publishing Department at the Museum undertook the yeoman's work of producing the lavish catalogue you hold in your hands. Sherry Babbitt, The William T. Ranney Director of Publishing, has been a fervent voice of support who gracefully encouraged me to craft the narrative while lending all her years of experience. It was a pleasure to learn from her. David Updike was the most rigorous and thoughtful editor a writer could ever ask for. Everything that follows reads better thanks to him. Richard Bonk astutely oversaw the book's production. Outside the Museum, Jo Ellen Ackerman created the boldly tasteful book design that would make Rubens himself proud. Graydon Wood and his colleagues in the Museum's Photography Studio provided the rich images of works in our collection that grace the catalogue.

For the physical exhibition, Jack Schlechter, The Park Family Director of Installation Design, and Jaime Montgomery brilliantly designed the immersive environment that I had always imagined for the powerful works of art in the show. That they did this while transforming a gallery in which nineteenth-century academic paintings normally hang is all the more astounding. Andy Slavinskas devised the lighting that turned the gallery into a space of high drama. Jeanine Kline and her colleagues in Facilities worked tirelessly behind the scenes. Martha Masiello, Eric Griffin, and the Museum's expert team of art handlers mastered the challenges of transporting and installing the large-scale objects in the show. Luis Bravo, Creative and Brand Engagement Director, gave the exhibition added style through his dynamic graphic designs. Maia Wind molded coherent and decipherable gallery texts. Jessica Sharpe, Director of Visitor Operations and Membership, marshalled her resources to help visitors get the most out of the experience.

To complement the exhibition, Marla K. Shoemaker, The Kathleen C. Sherrerd Senior Curator of Education, and her team enhanced our audiences' experiences with the art. On a personal level, Marla's encouragement to have fun with the show and the ideas it raises helped set the tone for me and others in the Museum. Ann Guidera-Matey, Victoria Fletcher, and all the guides enlivened the exhibition for our visitors. Lily Milroy, The Zoë and Dean Pappas Curator of Education, Public Programs, oversaw a range of programming, including the Anne d'Harnoncourt Symposium. At the University of Pennsylvania, the Museum's partner in the symposium, Larry Silver was a most adept co-organizer. Our conversations about the symposium, the exhibition, and numerous other topics always provided much food for thought.

I thank Jennifer Francis, Executive Director of Marketing and Communication, and her team, especially Norman Keyes, Matt Singer, and Chessia Kelly, for spreading word of the exhibition, and for finding creative and eloquent ways of doing so. Likewise, the web team—Bill Ristine, Sid Rodriguez, Brian Newell, and Jennifer Schlegel—ably trumpeted the exhibition on the Museum's website. William Weinstein, The John H. McFadden and Lisa D. Kabnick Director of Information and Interpretive Technologies, offered his sage advice and all manner of support for the practice and presentation of art history in the digital age. Special thanks go to Ashley Scrivener for her translation of exhibition content into digital presentation modules. Camille Focarino and her colleagues in Spe-

cial Events organized elegant events that celebrated the exhibition and everyone's contributions.

Penultimately, I want to extend special thanks to my teammates in this and other projects. Joshua Helmer, Assistant Director for Interpretation, and Ariel Schwartz, The Kathy and Ted Fernberger Associate Director for Interactive Technology, have been vocal advocates as well as thoughtful sounding boards during the various phases of investigation and implementation. Together they forged an accessible and compelling interpretive strategy for the exhibition in the gallery, online, and beyond. More so, they are true collaborators and friends who helped hone concepts, provided invigorating ideas, and identified the most apt channels for communicating them.

Mekala Krishnan, Collections Interpreter, dove in later, helping propel everything forward. Michele Frederick, Kress Interpretive Fellow in European Painting, made myriad contributions, from research assistance to logistical support, all with the utmost enthusiasm and leavening wit. I could not be more grateful for her close attention to detail.

Lastly, I want to acknowledge the contributions of my family. My wife, Sharon, is my guiding light. Her grace, intelligence, perseverance, and poise inspire me daily. From the first time I showed my son, Oliver, *Prometheus Bound* it became his favorite painting in the Museum. His sense of awe, wonder, and attraction to the painting's intense vitality spurred me to try to help others experience the painting as he does.

CHRISTOPHER D. M. ATKINS
The Agnes and Jack Mulroney Associate Curator of
European Painting and Sculpture before 1900

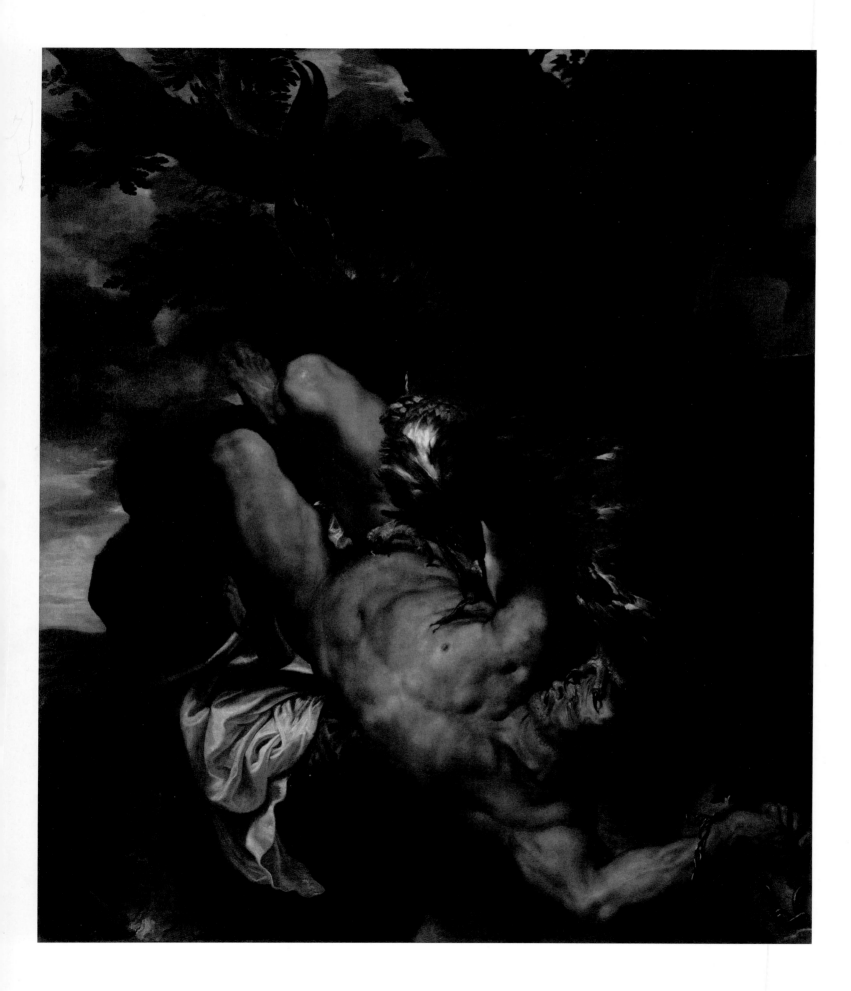

1 | SYNTHESIS

PROMETHEUS BOUND by Peter Paul Rubens and Frans Snyders (plate 1) is one of the most important Baroque pictures in the United States. Few seventeenth-century Flemish paintings of its size, ambition, and quality can be found outside of Europe. *Prometheus Bound* also occupies a special place in Rubens's oeuvre. In a 1618 letter, the artist himself granted it pride of place by listing it first among a selection of pictures he called "the flower of my stock." In the same letter, Rubens describes the painting: "A Prometheus bound on Mount Caucasus, with an eagle which pecks his liver. Original, by my hand, and the eagle done by Snyders."[1] This notation contrasts with the others on the list, which identify the assistance of apprentices and those in his workshop. With the exception of the eagle, Rubens painted every element of *Prometheus Bound*, from preliminary layers through to the finishing touches. As addressed in chapter 3, Snyders, as the preeminent painter of birds, was called on to participate, so that the picture operates as a duet between two masters. As we do today, Rubens clearly valued both the collaboration and the high level of his personal involvement in the execution of the painting.

Rubens painted *Prometheus Bound* at a formative time in his career. He had recently returned from eight years in Italy, where he studied and digested all manner of art, past and present. Back in Antwerp, he fused these inspirations with northern traditions to create a revolutionary style of painting that did much to define the Baroque movement of the early seventeenth century. In style, subject, and scale, *Prometheus Bound* exemplifies Rubens's approach to art as he was developing his innovative and transformative modes in Antwerp in the 1610s.

Despite the importance of the painting, *Prometheus Bound* rarely has been the subject of dedicated attention.[2] This catalogue and the exhibition it accompanies seek to rectify this by examining and celebrating Rubens's picture from its inception to its reverberation in the arts of seventeenth-century Europe and beyond. Each chapter explores a different facet of *Prometheus Bound*, placing the painting at the center of several coexisting narratives. This chapter looks at the myth of Prometheus and how Rubens, in formulating his interpretation of it, synthesized much of the great art of the past and present that he had absorbed in Italy and in his native Flanders. The next chapter locates the picture within Rubens's aesthetic of horror, which was steeped in a revival of the Stoicism of ancient Greece, a philosophy that emphasized emotional restraint in the face of physical and psychological torment. Chapter 2 also discusses how Prometheus came to be seen as a Christlike figure, and how Rubens's pictorial choices emphasize this connection. Chapter 3 shows how the subject provided Rubens with an opportunity to paint an intense, dramatic scene that also served as an allegory of creation and ambition. Chapter 4 considers why Rubens kept *Prometheus Bound* for six

years, and then charts its impact in the seventeenth century after the artist sent the picture, along with other paintings, to The Hague in 1618, in exchange for a collection of antique sculptures owned by the English ambassador, Sir Dudley Carleton. The book concludes with a brief coda surveying visual and literary approaches to Prometheus as a subject from the nineteenth century to the present, illuminating the continued relevancy of the story and of Rubens's moving visualization of it.

PROMETHEUS

The story of Prometheus—or stories, since it appears in multiple versions—is a rich one, with several key narrative moments.[3] The son of Iapetus and Asia, Prometheus was one of the Titans, the race of immortal giants who preceded the gods of Mount Olympus in Greek mythology. The Titans were ruled by Chronos until his son, Zeus, revolted against his father. A war broke out between the Titans and the Olympians in which the latter emerged victorious, forever banishing the Titans to secondary status in the pantheon of Greek deities. Prometheus sided with Zeus and thus fared better than his cohorts—at least until he deceived the ruling deity. In Hesiod's account, Prometheus presented Zeus with what he said was a sacrificial offering from mortals to settle their differences with the gods. In truth, it was a bundle of bones cloaked in glistening fat. Zeus was incensed and blamed humanity, whom he punished by hiding fire from them. In response, Prometheus stole the fire and gave it to the mortals. In the version of the story told by Aeschylus, this gift imbued human beings with the divine spark of creativity and reason. In either case, Zeus punished Prometheus by ordering Hermes and Hephaistos to chain him to Mount Caucasus, where an eagle visited him daily to devour his ever-regenerating liver.

Zeus also punished humanity by creating the first woman, Pandora. Prometheus warned his brother not to welcome her, but Epimetheus accepted Pandora as his bride. As a wedding gift, Zeus gave Pandora a box but instructed her never to open it. Overwhelmed by curiosity, she eventually opened the box and unleashed evil upon the world. Humanity has been coping with the consequences of Pandora's open box ever since, but Prometheus's punishment eventually ended when Hercules killed the eagle and freed the Titan.

The moral of Prometheus's story is ambiguous, and from even the earliest writings authors interpreted the tale differently: Hesiod focused more on Prometheus's actions as crimes, while Aeschylus crafted a more sympathetic figure who suffered for his good deeds. As this ambiguity exists within the narrative, it is no surprise that literary and visual artists continued to interpret the myth in varying ways. In Rubens's own time, leading Flemish and Dutch intellectuals such as Justus Lipsius (see chapter 2) and Karel van Mander wrote about the myth. As the Englishman Francis Bacon noted, Prometheus was "a common and hacknied fable" across Europe by the time Rubens returned to Antwerp in 1609.[4]

Most visualizations of Prometheus focus on a single narrative moment. As he did with myriad pictorial subjects, Anton Pigler attempted to document each instance in which an element of the myth of Prometheus served as the focus of a work of art in the seventeenth and eighteenth centuries.[5] Pigler found that artists of the period focused on four narrative moments: Prometheus forming humanity from clay, Prometheus stealing fire, Prometheus being punished, and Hercules freeing Prometheus. Far and away the most common were scenes of the hero's punishment, as in Rubens's *Prometheus Bound*. As we will see, in Rubens's time this subject was rich with associations—political, intellectual, and art historical—that would have resonated for the artist and his audiences.

RUBENS AND TITIAN

In 1771, the French antiquarian Jean François Marie Michel wrote of Rubens's distinctive style, "Venice was his idol for coloring, and Rome for his

correction of drawing."[6] Histories of the art of the Italian Renaissance—and, indeed, centuries of later European art—have been cast in these binary terms: the color and emotional force of the Venetians versus the carefully constructed compositions and figural poses of Roman and also Florentine artists. These dueling aesthetic ideologies are often personified, respectively, by Titian and Michelangelo. When it comes to Rubens, critics and historians from Michel to the present day have frequently cast him as a fusion or synthesis of these sixteenth-century artistic giants.[7] In many ways, *Prometheus Bound* exemplifies this synthesis more clearly than any other single picture. In his conception of the painting, Rubens drew from specific works of art by these two greats of the Italian Renaissance, as well as from antique sculpture, sixteenth-century Flemish artists, and his own contemporaries in the Dutch Republic. Moreover, his method of sampling from these diverse sources is indicative of early seventeenth-century Roman aesthetics. As a result, *Prometheus Bound* offers us an opportunity to delve deeply into Rubens's processes and their relation to contemporary artistic theories.

Rubens often drew direct, positive comparisons to Titian. In 1630 the Spanish poet Lope de Vega called him "the new Titian,"[8] an opinion that was later echoed by many others, including the Italian Giovanni Pietro Bellori (in 1672), the Frenchmen André Félibien (in 1679) and Roger de Piles (in 1681), and the Dutchman Arnold Houbraken (in 1718), all of whom linked Rubens to the colorist traditions of Venice, especially those proliferated by Titian.[9]

Rubens's interest in Titian was no doubt propelled by the Venetian artist's status as a court painter in his lifetime, as well as the popularity of his work among royal collectors after his death.[10] A native of the Veneto region, Titian began his career in Venice and worked for the doge and other luminaries of the Republic. His talents soon found wider audience, including Alfonso d'Este, Duke of Ferrara, and Federigo Gonzaga, Duke of Mantua. Pope Paul III commissioned paintings from him in the 1540s, and in 1548 the artist was invited to the Imperial Diet at Augsburg. From that point until his death in 1576 Titian worked almost exclusively for Charles V and other members and associates of the Habsburg dynasty.[11] These were the most prestigious patrons of the age, and by working for them Titian became the ideal of what a painter could accomplish in terms of ability, fame, status, and income.

It is not surprising, then, that for *Prometheus Bound* Rubens drew inspiration from Titian's painting of *Tityus* (plate 2) from 1548–49. Here, the giant Tityus endures his punishment for attempting to rape Leto, the mother of the gods Apollo and Artemis. Chained to the ground in the underworld of Hades, he is tormented by an enormous bird that tears at his endlessly regenerating liver. Titian chose this very moment of torment, showing Tityus writhing in pain as the bird penetrates the gaping wound on his chest to snatch the entrails in its hooked beak. The somber, muted grays and browns are pierced only by the blood-soaked liver and the crimson slash from which it emerges, and by the vibrant orange cloth from which the giant tumbles. With this monumental picture—the largest nonreligious painting on canvas of the entire Renaissance—Titian created a tour de force.

Due to the similar tortures they endured, Prometheus and Tityus were often confused for one another or seen as somewhat interchangeable. Tityus's tormentor in the original myth is a vulture, but both Titian and Michelangelo (among other artists) changed it to an eagle, further blurring the distinction. Indeed, some writers mistook the subject of Titian's great painting to be Prometheus.[12]

Although they depict different subjects, Rubens's *Prometheus Bound* is inconceivable without Titian's *Tityus* as precedent. Rubens staged a comparable hulking male nude chained to a rock who struggles against an enormous bird ripping out his internal organs. Both pictures also share the precarious placement of the figure within the composition, which enhances the unsettling effect of the scene on

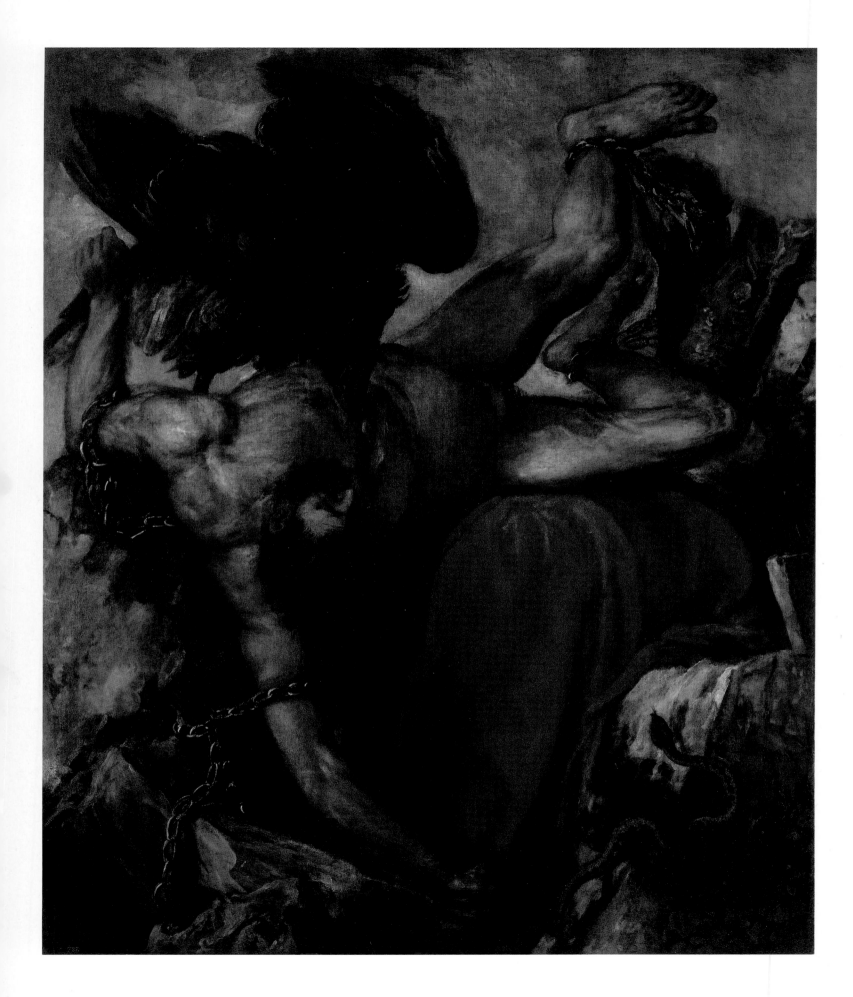

the viewer. Rubens even followed Titian's foreboding color scheme, though he chose to illuminate his figure and gave him more vital flesh tones.

Rubens turned to Titian's example often throughout his career. Most directly, the Flemish painter made several relatively faithful copies of paintings by Titian.[13] In other instances, Rubens appropriated and modified a model by Titian, as in his *Equestrian Portrait of the Duke of Lerma* of 1603 (fig. 1), in which he invokes Titian's equestrian portrait of Emperor Charles V of 1548 (Museo Nacional del Prado, Madrid) but makes several significant departures, such as placing his subject more frontally. Still, the monumental grandeur, evocative atmosphere, and brimming vitality of the canvas all relate directly to Rubens's Venetian inspiration.

Though Rubens was a prolific and accomplished draftsman, there are no known drawings by him after paintings by Titian. Rather, he issued his responses to the Venetian master in the distinctive medium of oil paint, whether in sketches or on finished canvases. Titian famously created his paintings without a drawn preparatory design because he thought in color and in paint. His subtle gradations in tone and hue ebb and flow to create rich surfaces that delight the eye. Titian wielded his brush like a ribbon, creating swirls, loops, and strokes of undulating thickness that dance across the canvas. In many passages, these strokes are not blended out, but stand as articulated marks and as traces of the act of applying paint to canvas.[14] In this approach, Titian was the unquestioned master. As the Italian artist and writer Giorgio Vasari noted in his seminal *Le vite de' più eccellenti pittori, scultori, e architettori* (Lives of the most excellent painters, sculptors, and architects) of 1550, Titian's late paintings "are executed with bold strokes and dashed off with a broad and even coarse sweep of the brush, insomuch that from near little can be seen but from a distance they appear perfect."[15] The Dutch writer and theorist Karel van Mander, in his *Schilderboek* (Book of painters) of 1604, said that it was harder to paint like Titian than like any other artist.[16]

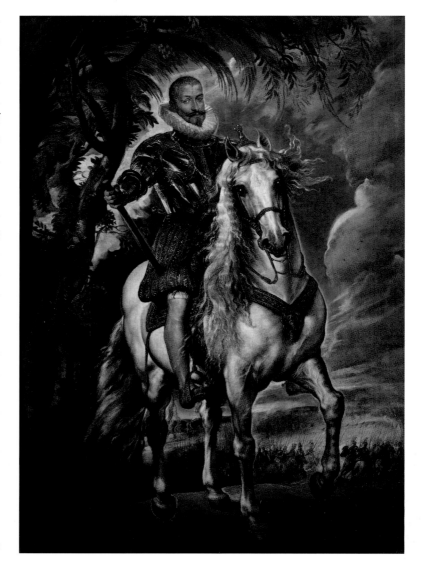

Fig. 1. Peter Paul Rubens. *Equestrian Portrait of the Duke of Lerma,* 1603. Oil on canvas, 9 feet 6 inches × 6 feet 10 inches (2.9 × 2.1 m). Museo Nacional del Prado, Madrid

Plate 2
TITIAN
(Italian, c. 1488–1576)
Tityus
1548–49
Oil on canvas
99⅝ × 85⅞ inches
(253 × 217 cm)
Museo Nacional del Prado, Madrid

Rubens could only respond to the full range of Titian's aesthetic after seeing the paintings in the flesh; reproductive prints or drawn copies could not convey the breadth of Titian's mastery. Rubens had considerable first-hand knowledge of Titian's paintings and seems to have sought out opportunities to see them. When the Flemish artist arrived on the Italian peninsula in 1600 his first stop was Venice, where he could explore many paintings by Titian in situ. While in Venice Rubens also met Vincenzo Gonzaga, the Duke of Mantua, and later joined him in Mantua, where the young artist encountered numerous paintings by Titian in the ducal collection.[17] In 1603, as an envoy of the

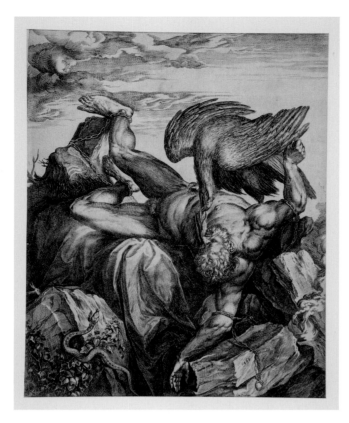

Fig. 2. Cornelis Cort (Dutch, c. 1533–1578) after Titian (Italian, c. 1488–1576). *Tityus Punished in Hell*, 1566. Engraving, 15¼ × 12⅜ inches (38.8 × 31.5 cm). Yale University Art Gallery, New Haven

Duke of Mantua, Rubens spent ten months in Spain—then, as now, home to the greatest assemblage of Venetian painting. The artist traveled to Madrid and Valladolid and reported that he was much impressed by the paintings by Titian in the royal collections in both cities.[18] It was in Spain that Rubens saw *Charles V on Horseback* and painted his portrait of the Duke of Lerma inspired by it.[19]

Although scholars have long linked Rubens's *Prometheus Bound* to Cornelis Cort's reproductive print after *Tityus* (fig. 2), it seems likely that Rubens saw Titian's original canvas during his stay in Spain. The Spanish Habsburg governor of the Netherlands, Mary of Hungary, had commissioned the Venetian artist to paint *Tityus* for her palace at Binche, just sixty-eight miles from Rubens's hometown of Antwerp, but the painting was transferred to Madrid before 1566, where it became part of the Spanish royal collection that Rubens saw on his 1603 journey. He may have had cause to seek out *Tityus* in particular. Indeed, it is not a stretch to say that the painting was already famous by the dawn of

the seventeenth century. Cort's engraving had circulated the image, and Vasari had discussed *Tityus* and noted its location in his *Lives*.[20] Rubens owned a copy of Vasari's book, so he would have known of the painting and where to find it. Given that *Prometheus Bound* is but five inches shorter and two inches narrower than Titian's massive canvas, it is reasonable to conclude that Rubens spied the picture on his first Iberian voyage and intentionally issued his response on nearly the same scale.

Rubens's choice of *Tityus* as a model for *Prometheus Bound* speaks to his ambition as a painter (see chapter 3). Over the course of his career, Rubens would equal Titian in distinguished clientele and accompanying accolades, becoming the most sought-after artist of his day. In 1609, shortly after his return to Flanders from Italy, he had been appointed official court painter by the Habsburg governors of the southern Netherlands. In 1621 he received a commission for a cycle of twenty-five paintings for the ruling regent of France, Marie de' Medici. Later, Rubens worked for King Philip IV of Spain as a painter and a diplomat. For his varied services to the Spanish crown he received a patent of nobility in 1624. In 1630 he was knighted by King Charles I and subsequently painted a suite of ceiling panels for the king's Banqueting House at Whitehall in London. Rubens emulated Titian's way of working—and, in a sense, his career trajectory as artist to the courts of Europe—not only because he admired the Venetian's aesthetic, but also because he sought to cast himself as an artist of the first rank.

RUBENS AND MICHELANGELO

As much as Rubens looked to Titian's example, he also developed a deep understanding of the art of Michelangelo. In the case of *Prometheus Bound*, Michelangelo's finished drawing *Tityus* (plate 3a) has long been recognized as a fundamental source.[21] Indeed, Titian's *Tityus* also developed, in part, in dialogue with Michelangelo's treatment of the subject.[22]

Rubens derived his pose for Prometheus almost directly from that of Michelangelo's Tityus,

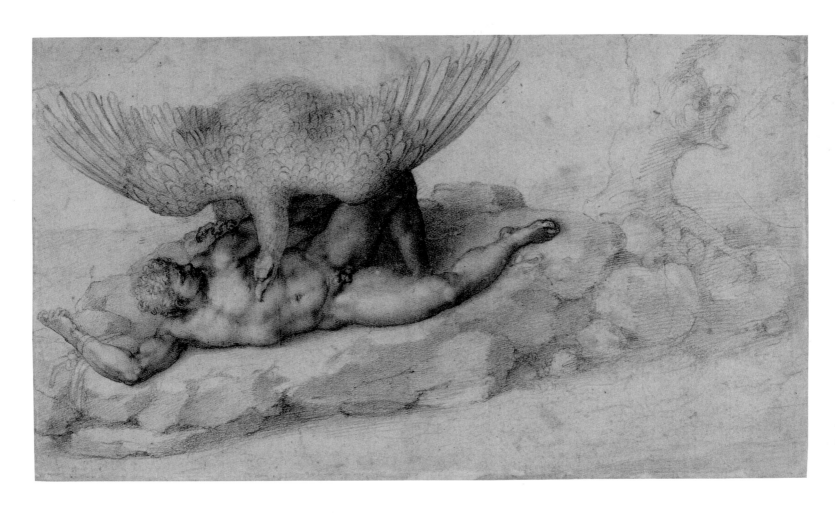

Plate 3a

MICHELANGELO BUONARROTI
(Italian, 1475–1564)
Tityus (recto; see page 19 for verso)
1532
Black chalk on paper
7½ × 13 inches (19 × 33 cm)
The Royal Collection / Her Majesty
Queen Elizabeth II

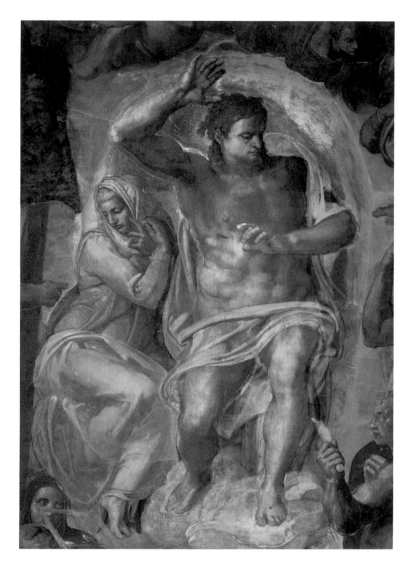

Fig. 3. Michelangelo Buonarroti. Detail of the Risen Christ from *Last Judgment*, 1536–41. Fresco. Sistine Chapel, Vatican Palace, Vatican

Tityus is not heroic in the sense that the character was valorous. Rather, he boasts a body that would seem to represent masculine perfection in its balanced proportions and evenly distributed masses of muscle. Michelangelo even exposed Tityus's genitalia so that nothing cloaks his body. Rubens was more modest in providing a sliver of drapery between Prometheus's legs, but otherwise offers a rather complete view of his figure, even if foreshortened. With the exception of the Prado *Tityus*, Titian and his Venetian contemporaries rarely turned to the nude male, though they frequently depicted female nudes. Alternatively, Michelangelo often found opportunities to focus on masculine bodies that, like classical sculpture, lacked clothes or drapery. Michelangelo's male nudes are massive, with voluminous muscles covering a broad frame.[23] Portraiture from the period indicates that typical male proportions were much leaner, especially among the social and ecclesiastical aristocracy, whose members did not perform physical labor.[24] Michelangelo's figures must have appeared superhuman in comparison. Such representations were perfectly fitting for gods, Titans, and Christ, who were not ordinary humans. In the case of the tortured Tityus, the perceptible strength communicated by his physical form also shows the severity of the attack, as even the most miraculous of bodies is rendered powerless.

Another key feature that Rubens adopted from Michelangelo was to present his figure with just a modicum of facial hair. As Titian's *Tityus* and his various Habsburg portraits suggest, bearded adult male figures were the norm in sixteenth- and seventeenth-century art. In fact, after Pope Julius II decided to grow out his beard in 1510, facial hair dominated male fashion throughout Europe.[25] Many of Michelangelo's male figures, including *Tityus*, lack this secondary gender mark. Most famously, the Risen Christ (fig. 3) in the *Last Judgment* on the wall behind the altar in the Sistine Chapel is clean-shaven. This was a conscious decision on the part of Michelangelo, as iconographic tradition dating back to the fourth century favored a bearded Christ. Why Michelangelo preferred

though he reoriented the figure on the canvas. Both figures feature an upraised arm that culminates in a clenched fist, and both turn their heads over the opposite shoulder to lock eyes with the swooping predator. Rubens has escalated the drama, especially as Prometheus's torso bears the wounds caused by the piercing talons of the eagle painted by Snyders. While Titian's figure topples and almost doubles over, collapsing the view of the torso, Rubens followed Michelangelo in crafting a fully exposed abdomen, enabling him to articulate each of the giant's rippling abdominal muscles.

Michelangelo's interest in heroic nude males inspired Rubens generally. The Florentine painter's

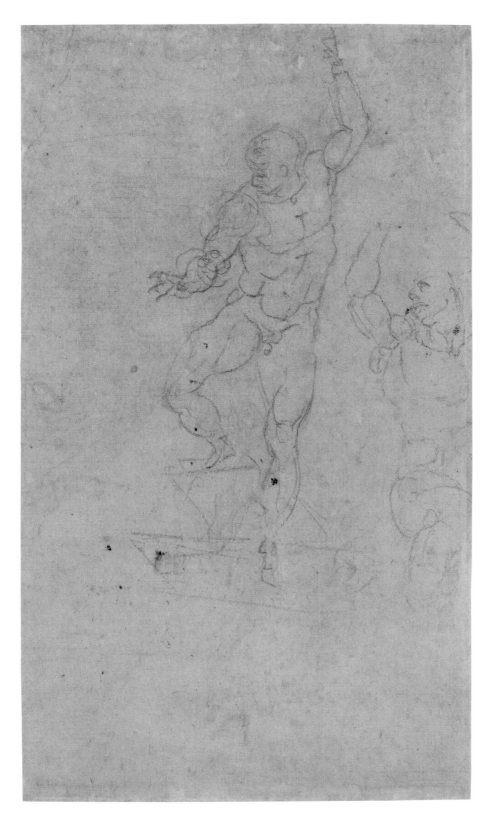

Plate 3b
MICHELANGELO BUONARROTI
A Sketch of the Resurrected Christ
(verso; see page 17 for recto)
1532
Black chalk on paper
13 × 7½ inches (33 × 19 cm)
The Royal Collection / Her Majesty
Queen Elizabeth II

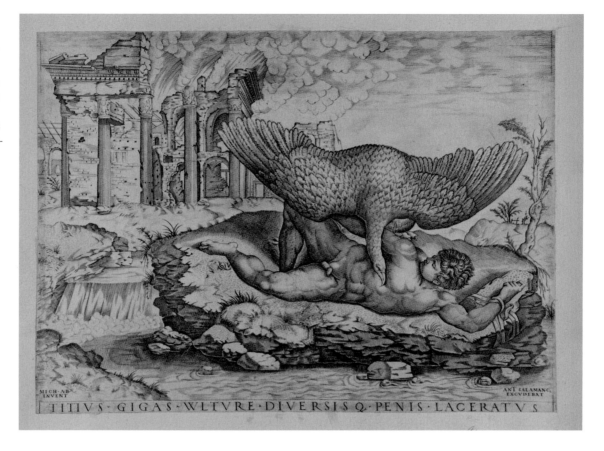

beardless faces for his male figures is uncertain. He may have been harkening back to an earlier aesthetic, or he may have sought to distinguish his figures from the realm of the common man, as he did in providing them with muscular physiques. Prometheus is not clean-shaven, but his beard is thin and unobtrusive. Indeed, from a distance his face resembles that of the Sistine Risen Christ.

In truth, more than Prometheus's face recalls Michelangelo's central figure from the *Last Judgment*. Rotate Prometheus one-third of a turn counterclockwise, and you have something like a mirror image of Christ. Michelangelo performed a similar experiment on the reverse of the Windsor Castle drawing, where he reoriented the pose of his Tityus to sketch the Risen Christ (plate 3b). Rubens certainly would have seen this sketch, though we do not know if it influenced his decision to reorient the figure for his Prometheus. The Christological implications of Prometheus as

a subject will be examined in the next chapter; for now it is important to recognize Rubens's broad interest in Michelangelesque male figures.

Scholars have generally assumed that Rubens encountered *Tityus* in a reproductive print, such as that by Nicolas Beatrizet (fig. 4), but it is more likely that he saw the drawing during his second sojourn to Rome, between 1606 and 1608. As with Titian's version of the subject, Michelangelo's *Tityus* was already famous in Rubens's lifetime. In addition to having been circulated in print, the drawing was praised by Vasari in his *Lives*.[26] Michelangelo gave *Tityus*, along with other of the so-called presentation drawings, to his companion, Tommaso de' Cavalieri.[27] By 1602, it was in the collection of Cardinal Odoardo Farnese in Rome.[28] Rubens made drawings after the Farnese Hercules when the colossal sculpture was in the courtyard of the cardinal's residence at the Palazzo Farnese, and Michael Jaffé and others have noted

the artist's intimate familiarity with the ceiling frescoes painted there by Annibale Carracci.[29] It would be surprising if Rubens, an enthusiastic admirer of Michelangelo, had not sought out the opportunity to see *Tityus* given his access to these other parts of the cardinal's collection.[30]

Rubens's affinity for Michelangelo's drawings and the aesthetic they communicated extended to his personal collection as well. The Flemish artist owned several drawings by Michelangelo, as well as drawings by other artists who reproduced Michelangelo's work. Jaffé has argued that Rubens not only owned the faithful replica by Giulio Clovio of Michelangelo's *Ganymede*, another presentation drawing to Cavalieri, but that he may have retouched it as well.[31] Michael Hirst has suggested that a drawing of a standing male nude (now in the Albertina, Vienna), which has often been connected to Michelangelo and his circle, was once owned by Rubens as it bears the inscription "CPP Rub———."[32] Jeremy Wood has posited that the drawing of Hercules by Bartolomeo Passarotti after Michelangelo was retouched by Rubens when he owned it.[33]

Though Michelangelo's fame stemmed from his public works in the arenas of sculpture, painting, and architecture, he was also widely admired for his drawings. In fact, it was through drawings that Michelangelo's talent was first recognized by his contemporaries. Most notably, Vasari devoted several passages to the artist's draftsmanship and mentioned *Tityus* by name in his extended biography in the *Lives*.[34] In his discussion of the Sistine Chapel ceiling, Vasari wrote that in these frescoes Michelangelo "resolved to show modern craftsmen how to draw and paint."[35] At first glance this may seem to be a curious statement—how can a finished painting teach others to draw? The answer is because drawing was believed to be the foundation of all two-dimensional art, and Michelangelo's paintings made explicit reference to the drawings that preceded them. In this sense, drawing was related to the aesthetic component known in Italian as *disegno*, a word that can be translated as both "drawing" and "design."[36] *Disegno* covered every-thing from creative forethought to composition to the execution and placement of the individual lines that marked the forms and concept of a design. Though often associated with study, planning, and preparation for another work, drawing was also the perfect vehicle not only for working out and registering design, but also for communicating designs and design concepts to others. According to some theories of art in Michelangelo's day, *disegno* was the most valued aesthetic. Michelangelo's art constituted the epitome of *disegno*, and as a finished drawing, *Tityus* was perhaps the perfect exemplar. It is not a sketch, but rather a rigorously plotted and executed work of art that stands as a design for itself. Moreover, the individual lines with which Michelangelo locked his forms, shadows, and highlights all read as perfect strokes of draftsmanship.

Like so many others, Rubens admired Michelangelo's *disegno*. While Rubens executed painted copies and studies of Titian, he almost always drew his direct responses to Michelangelo's work.[37] Likewise, Rubens favored drawing after Michelangelo's two-dimensional works. Many sheets survive on which Rubens drew after antique sculpture, but none on which he directly engaged with that of Michelangelo.[38] In contrast, Wood has attributed to Rubens at least seventeen drawings after portions of the Sistine Chapel decoration alone.[39]

In *Prometheus Bound*, we can see how Rubens distilled and appropriated elements of Michelangelo's *disegno*. The figure is sharply and precisely drawn, so that one can almost trace the outline of Prometheus's knees, feet, torso, and arm. In order to render Prometheus with such anatomical accuracy, Rubens must have studied and prepared himself before applying brush to canvas. The overall design of the composition echoes that of *Tityus* as well as Michelangelo's paintings, especially the central panels from the Sistine ceiling. Like Michelangelo, Rubens restricted himself to a single narrative moment of high tension experienced by an extremely limited number of figures. More so, the figures fill the pictorial space and lay flush against the picture plane. Neither artist has carved much

depth within which his figures can operate. Likewise, details are largely eschewed in favor of intense focus on a heroic, nude human form. In these ways Rubens, like Michelangelo, was able to communicate his clear mastery of the *disegno* aesthetic.

RUBENS AND THE LAOCOÖN

In addition to the art of the recent past, Rubens also steeped himself in the achievements of antiquity. Among the most significant of ancient sculptures for the artist, especially in the 1610s, was the Laocoön (fig. 5). This emblematic Hellenistic Greek sculpture, then (as now) in the collection of the Vatican, depicts the legend from Virgil's *Aeneid* of the Trojan priest Laocoön, who warned his fellow citizens not to let the wooden horse delivered by the Greeks into the city. To silence the priest's warnings the goddess Athena sent giant snakes to kill him and his two sons. As will be discussed in greater detail in chapter 2, the Laocoön provided Rubens, as well as his predecessors Michelangelo and Titian, with an antique model for the exploration of pain and suffering. Formally, the sculpture also offered an intense, dynamic pose and an ideal muscular male form, both of which these artists readily adapted.

Probably sculpted sometime in the first century CE, the Laocoön was a widely circulated image in the sixteenth and early seventeenth century.[40] Discovered in 1506 in an underground room in a vineyard in Rome, the large-scale sculpture was almost completely intact and in excellent condition. Moreover, the dynamism of the struggling bodies and the intense emotion of the priest's face made it unlike any work of art from antiquity then known. The ancient historian Pliny had praised the sculpture as "superior to all the pictures and bronzes in the world," but no image of it had survived until the sculpture was found.[41] Thus not only was the Laocoön visually revolutionary, it also had been heralded in a revered and widely known ancient source. As a result, it quickly became one of the most famous works of art in Europe.

Michelangelo was deeply enamored with the Laocoön. He was present at the authentication of the sculpture in 1506 and appropriated it in several of his works. To take but two, both the Risen Christ in the Sistine *Last Judgment* (see fig. 3) and the drawing of Tityus (see plate 3a) are unthinkable without this Hellenistic model. In both instances, Michelangelo employed the priest's pose and chiseled body almost precisely. Interestingly, the Florentine artist stripped the emotional tension from his appropriations of the Laocoön. Neither Christ nor Tityus displays the furrowed brow or open-mouthed yawp of the sculpture. Likewise, Michelangelo preferred clean-shaven faces to the priest's tressed beard.

Though his interests in antique sculpture are not as widely recognized, Titian also looked to the Laocoön for inspiration. Miguel Falomir has recently outlined its impact on Titian, tracing both the artist's *Tityus* (see plate 2) and his *Coronation* of 1540 (Musée du Louvre, Paris) to the ancient marble.[42] The indebtedness of *Tityus* to the sculpture is clearer, though it is a less literal emulation than Michelangelo's. The nude male form with powerful torso, splayed legs, and bearded face references the priest, as does the painting's overall mood of emotional defeat.[43] Falomir posits that Pliny's description of the Laocoön as the ultimate work of art likely spurred Titian to try to best the ancient masterpiece. What would be more impressive than creating a work that outshone even the most prized object of all antiquity? The same argument could well apply to Michelangelo.

Rubens's own engagement with the Laocoön was multilayered. Like Michelangelo and Titian, he no doubt sought out the sculpture in the spirit of admiration and competition. In his efforts to make high art, he wished to have his works judged against the best in history, and the Laocoön certainly met this criterion. Emulating the marble also enabled Rubens to be judged against Michelangelo and Titian, since they too had famously appropriated aspects of it. Thus, Rubens attempted to surpass not only the best of the ancients, but also

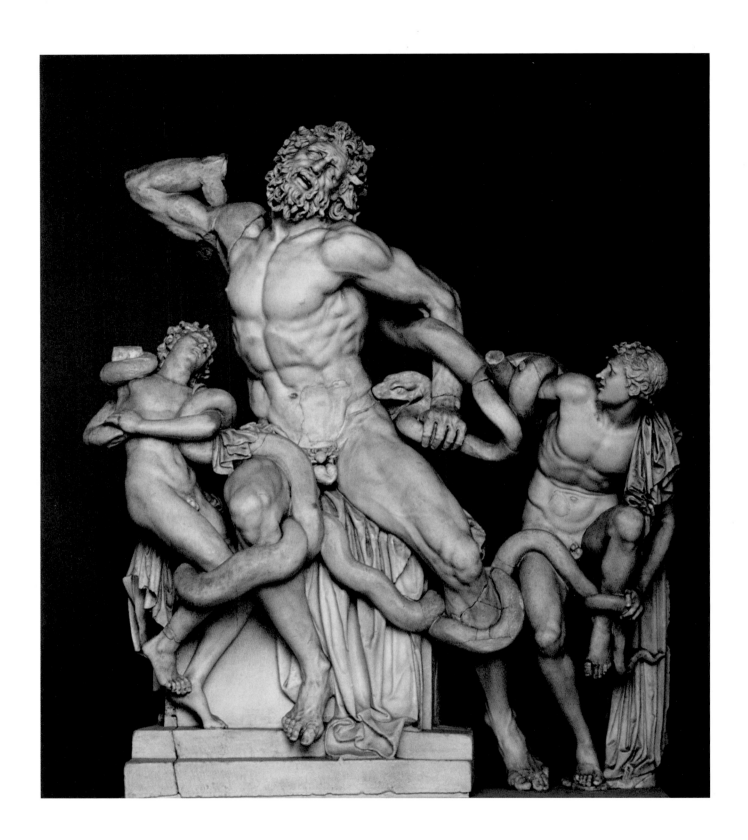

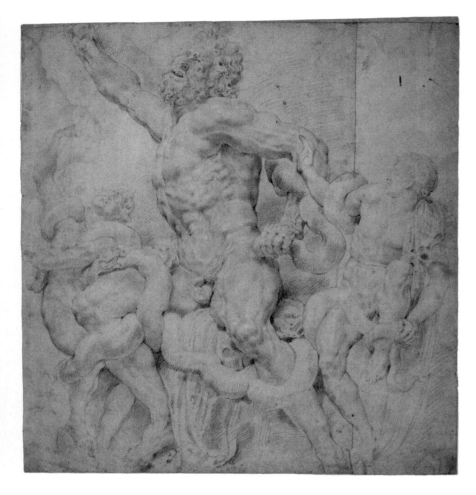

Fig. 6. Peter Paul Rubens. *Laocoön and His Sons*, c. 1606–8. Black and white chalk, bistre wash on paper; 18¹¹⁄₁₆ × 18¹¹⁄₁₆ inches (47.5 × 47.5 cm). Biblioteca Ambrosiana, Milan

those modern artists who had previously tried to reach the Laocoön's heights. Rubens's emulations also indicate that he digested not only the achievements of Michelangelo and Titian, but also their source material.

The artist's encounter with the Laocoön is documented by a drawing, now in Milan (fig. 6), that he no doubt made during his time in Rome in 1606–8. Rubens opted for an oblique angle, perhaps to capture the anguish registered on the priest's face, but accurately recorded all elements of the composition. He kept drawings like this for later reference, and the Milan drawing would have allowed him to enhance his recollections and rework the antique prototype in his own paintings. Rubens clearly had the Laocoön deeply in mind as he painted both *Prometheus Bound* and the *Descent from the Cross* in the 1610s.

Rubens's *Descent from the Cross* of 1617–18 (Church of Our Lady, Antwerp) and the print by Lucas Vorsterman (plate 4) that reproduced it have long been linked to the Greek sculpture.⁴⁴ In the painting, Rubens reversed the orientation so that Christ's left arm rather than his right is raised.⁴⁵ Likewise, the overall S-curve of the figure that begins in the arm, bows through the torso, and flexes out in the opposite direction through the legs has been flipped. Rubens even appropriated the pose of the son of the Trojan priest on the right for the figure standing on the ladder. In Vorsterman's print, all of these features are reversed so that the image accords even more directly with the sculpture. Part of Rubens's genius in the employment of the Laocoön as model is that he transformed the priest's struggle against the snakes into Christ's heavy stillness, transferring the burden and strain to those who bear his weight as they remove him from the cross.

The formal links between the Laocoön and *Prometheus Bound* are equally strong. Here again, Rubens reversed the pose of the Trojan priest and rotated him 180 degrees. Otherwise, he has appropriated much of the body verbatim, though he altered the face and the facial hair. Like Laocoön, Prometheus is a vital being in active combat with an animal assailant. As Michelangelo and Titian had done before him, Rubens turned to the antique sculpture as a model for the figuration of pain and anguish. The artist also embraced the opportunity to compete with the work of art that was deemed the crowning achievement of antiquity. In so doing, Rubens measured himself, and asked to be measured by others, against the best of the ancient and modern worlds.

RUBENS AND THE NORTH

While much of Rubens's overall conception of the scene in *Prometheus Bound* is unquestionably indebted to the examples of Titian, Michelangelo, and the Laocoön, the decision to place the central figure at such a dramatic angle was inspired by sources north of the Alps. Most notably, *Prometheus*

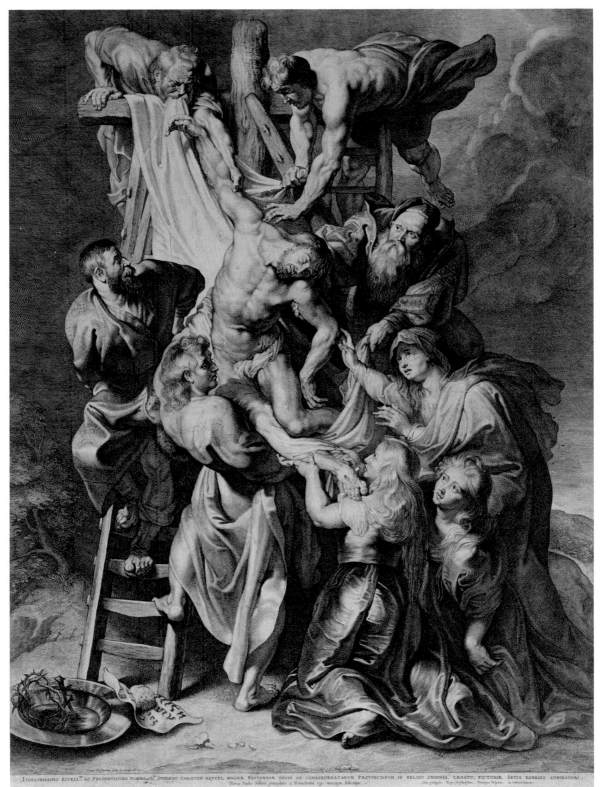

ILLVSTRISSIMO ECCELL.mo AC PRVDENTISSIMO DOMINO.o D.o DVDLEYO CARLETON EQVITI, MAGNÆ BRITANNIÆ REGIS AD CONFŒDERATARVM PROVINCIARVM IN BELGIO ORDINES, LEGATO, PICTORIÆ ARTIS EGREGIO ADMIRATORI.
Petrus Paulus Rubens, pingebat et benevolentiæ ergo nuncupabat, dedicabatque.

Plate 4
LUCAS EMIL VORSTERMAN I
(Flemish, 1595–1675)
after **PETER PAUL RUBENS**
Descent from the Cross
1620
Engraving
Sheet: 22¾ × 17¹⁄₁₆ inches
(57.8 × 43.3 cm)
Philadelphia Museum of Art.
The Muriel and Philip Berman
Gift, acquired from the John S.
Phillips bequest of 1876 to the
Pennsylvania Academy of the
Fine Arts, 1985-52-15165

Plate 5

MICHIEL COXCIE I

(Flemish, 1499–1592)

The Death of Abel

1539

Oil on canvas

59½ × 49¼ inches

(151 × 125 cm)

Museo Nacional del

Prado, Madrid

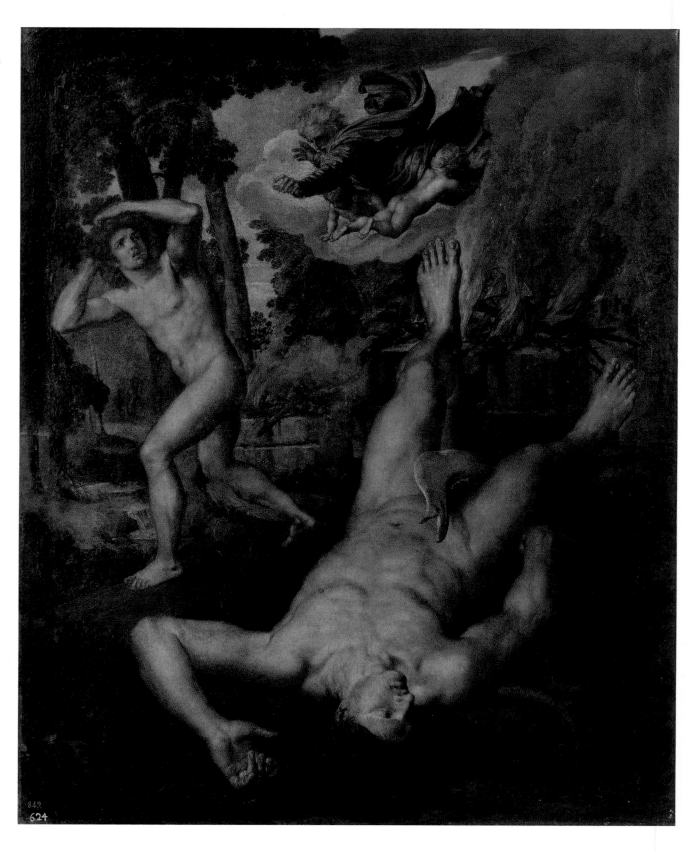

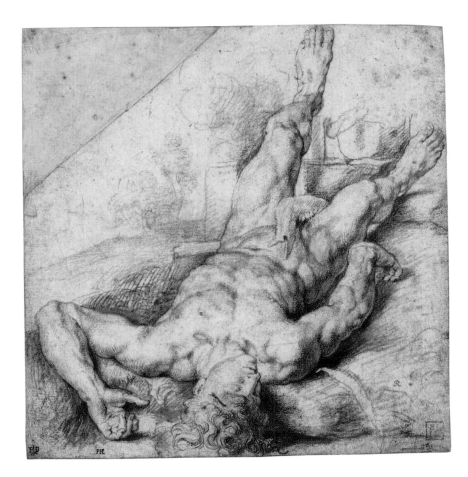

Fig. 7. Michiel Coxcie I, retouched by Peter Paul Rubens. *Abel Slain by Cain*, after 1539; retouched in the seventeenth century. Red chalk and whitening on paper, 8⁷⁄₁₆ × 8¼ inches (21.4 × 21 cm). Fitzwilliam Museum, Cambridge

Fig. 8. Peter Paul Rubens. *Cain Slaying Abel*, c. 1608–9. Oil on panel, 51¹¹⁄₁₆ × 37¹⁄₁₆ inches (131.2 × 94.2 cm). Samuel Courtauld Trust, The Courtauld Gallery, London

Bound has much in common with Michiel Coxcie's *Death of Abel* from 1539 (plate 5). Here, Coxcie foreshortened his fallen figure with head down at the edge of the canvas.[46] Like Prometheus, Abel has his left arm bent with his hand reaching above his head, which is turned to the right. Their thick, broad chests and clean-shaven faces have much in common as well. Even the jawbone with which Cain has struck his brother, placed precariously between Abel's legs, foreshadows the snippet of white satin that masks Prometheus's genitals.

Art historians have not linked Coxcie's painting to Rubens's Philadelphia canvas, but Rubens knew its composition well. King Philip II transferred *Death of Abel* to the royal residence at San Lorenzo de El Escorial in 1584, where Rubens likely saw it in 1603. Rubens also owned and retouched a drawing by Coxcie of the figure of Abel (fig. 7).[47] Fiona Healey has argued that Rubens's *Cain Slaying Abel* of 1608–9 (fig. 8) is a direct response to Coxcie's

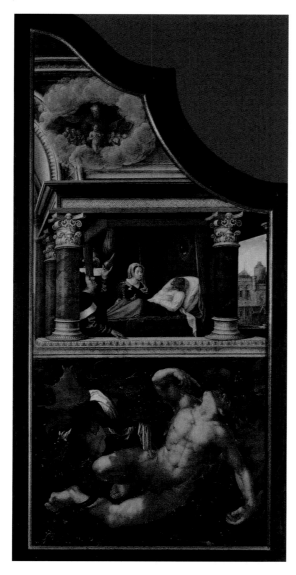

Fig. 9. Bernard van Orley (Flemish, c. 1488/92–1541/42). Detail of *Triptych of the Virtue of Patience*, 1521. Oil on oak panel, 68½ × 27⁹⁄₁₆ inches (174 × 70 cm). Musées Royaux des Beaux-Arts, Brussels

lands, probably born in Mechelen, Coxcie spent the 1530s in Italy, where he came to know Michelangelo and Vasari and corresponded with Titian.[49] According to Vasari, the artist won several prominent commissions, including painting frescos for the old basilica of Saint Peter's in Rome.[50] After returning to the southern Netherlands around 1540, Coxcie became a court painter in Brussels in 1546, though it is not clear whether he served Emperor Charles V or Mary of Hungary. In either case, Coxcie painted fresco decorations at Mary of Hungary's palace at Binche, the same location for which Titian's *Tityus* was designed. After the joint abdication of Charles V and Mary of Hungary in 1555, Coxcie began working for Philip II, sending paintings to the Spanish monarch from Brussels. Eventually, Coxcie settled in Mechelen, which, after the establishment of an archbishopric in the city in 1559, was the Catholic heart of the southern Netherlands. There, Coxcie executed numerous prominent altarpieces and became the leading painter of the first wave of the Flemish Counter-Reformation, while also continuing to work for important clients back in Brussels.

Koenraad Jonckheere has posited that Coxcie was Rubens's forerunner in the southern Netherlands.[51] Both artists worked successfully for church and court patrons of the highest level. More specifically, Coxcie was a Flemish artist in the employ of both a Habsburg monarch and his governor in Brussels before Rubens entered the employ of King Philip IV and Archduke Albert and Archduchess Isabella in Brussels. Like Coxcie before him, Rubens achieved this international stature after an extended early period in Italy. And, from an aesthetic perspective, both artists did much to introduce and circulate the styles and forms of contemporary Italian painting in northern Europe.[52] Perhaps Rubens, who had recently returned from Italy and been appointed court painter in Brussels when he executed *Prometheus Bound*, felt this strong connection. He may have adapted Coxcie's *Death of Abel* not only as an exemplar of foreshortening, but also as a means to

painting, presumably mediated through the drawing.[48] Healey suggested that Rubens took Coxcie's composition as a point of departure and sought to better it. Rubens's decision to reference Coxcie's painting in both *Cain Slaying Abel* and *Prometheus Bound* indicates his admiration for Coxcie's invention, and, perhaps, a desire to position his own work in relation to an esteemed master in the local pictorial traditions.

Though he is not well known today, Coxcie was one of the giants of late sixteenth-century European painting. A native of the southern Nether-

pay homage to his esteemed predecessor, and even to evoke Coxcie in the minds of his viewers.

By engaging with Coxcie's figure of Abel, Rubens also created a painting that was very much attuned to recent local interests. Indeed, much sixteenth-century art in the southern Netherlands featured male nudes in related, dramatically contorted poses. One of the earliest examples is the *Triptych of the Virtue of Patience* of 1521 (fig. 9) by Bernard van Orley, Coxcie's probable teacher.[53] On the exterior of the right wing is an arresting image of the parable of the rich man. At center, the rich man lies on his deathbed in his luxurious bedchamber. At bottom, he appears in hell, stripped of his clothes and tormented by thirst and a throng of demons. The C-curve of the figure ripples with tension, as Van Orley experimented with how to convey extreme discomfort through bodily contortion.[54] Van Orley's triptych was most likely installed in the Church of Notre-Dame du Sablon in Brussels, a highly accessible site.[55]

In Antwerp, Coxcie's contemporary Frans Floris frequently painted writhing, nude male figures, especially after his return in 1546 from a two-year sojourn in Italy. Most important in this regard is

Fig. 10. Frans Floris the Elder (Flemish, 1519–70). *The Fall of the Rebel Angels*, 1554. Oil on panel, 10 feet 1 inch × 8 feet 3 inches (3.1 × 2.2 m). Koninklijk Museum voor Schone Kunsten, Antwerp

Fig. 11. Michelangelo Buonarroti. Detail of the Damned from *Last Judgment*, 1536–41. Fresco. Sistine Chapel, Vatican

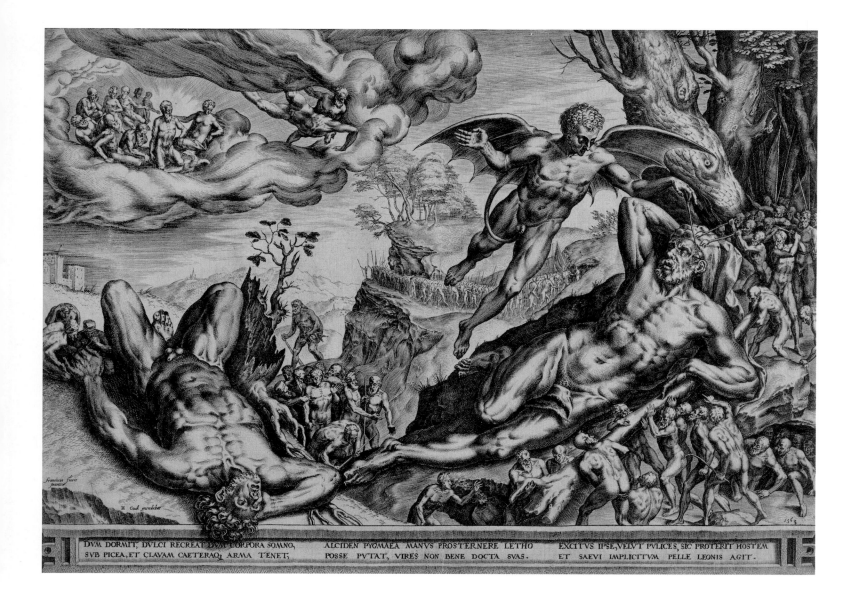

Plate 6

CORNELIS CORT

after **FRANS FLORIS THE ELDER**

Hercules and the Pygmies

1563

Engraving

Sheet: 12¹⁵⁄₁₆ × 18¼ inches (32.8 × 46.4 cm)

Philadelphia Museum of Art. The Muriel and Philip Berman Gift, acquired from the John S. Phillips bequest of 1876 to the Pennsylvania Academy of the Fine Arts, 1985-52-29575

Floris's *Fall of the Rebel Angels* of 1554 (fig. 10), painted for the altar of the Fencers' Guild in the Church of Our Lady in Antwerp, the same cathedral for which Rubens painted the *Raising of the Cross* in 1610–11 (see fig. 19) and the *Descent from the Cross* in 1612–14.[56] In its densely interwoven mass of sprawling figures banished from heaven, Floris closely followed Michelangelo's Sistine *Last Judgment*, which had been completed in 1541. The monstrous heads of some of the fallen, such as the figure with hair of coiled snakes at center and that with horns in the bottom left-hand corner, recall the fantastic figures in the lower right-hand quadrant of Michelangelo's fresco (fig. 11). The avenging angels are fully clothed, but their monstrous enemies are nude, revealing flexing and contracting muscles that communicate extreme physical exertion.

In 1563 in Antwerp, Cort produced *Hercules and the Pygmies* (plate 6), an engraving from a design by Floris that relates closely to *Prometheus Bound*.[57] The subject is taken from an *ekphrasis* in *Icones* by the second-century Greek Sophist Lucius Flavius Philostratus.[58] In the engraving, Hercules's vanquished wrestling foe Antaeus lies defeated at left, while the hero awakens from his post-match slumber to be threatened by an army of diminutive adversaries. For the sprawling body of Antaeus, Floris transferred the pose from a religious subject, the Fall of the Rebel Angels, to a secular and mythological one. The artist heightened the sense of precarious space by having Antaeus's head overlap the lower border, as if he were spilling out of the picture and entering the domain of the viewer. Cort's engraving did much to circulate the composition and proliferate the pose. Though he admitted to having seen none of Floris's paintings, Vasari mentioned *Hercules and the Pygmies* by name.[59] Along with the diverse imagery by Coxcie and Floris, Cort's engraving suggests that this pose and its association with defeated or dead antiheroes were deeply embedded in the visual culture of Antwerp in the late sixteenth century. It is reasonable to conclude that Rubens, in adapting the pose for *Prometheus Bound*, was responding to the

tradition of Floris as much as that of Titian, Michelangelo, and the Laocoön.

Coxcie, Floris, and Cort also were among the myriad northern European artists who responded to the paintings of Michelangelo. Coxcie and Floris in particular played significant roles in disseminating Michelangelesque aesthetics, especially those found in the Sistine *Last Judgment*, north of the Alps. This trend continued into the early decades of the seventeenth century with Rubens and several of his contemporaries.

Dutch artists in particular seem to have been drawn to Michelangelo's use of the contorted, tormented male nude figure. Cornelis van Haarlem's *Two Followers of Cadmus Devoured by a Dragon* of 1588 (National Gallery, London) reproduces the same scene from Michelangelo's Sistine ceiling that Rubens recorded in *Israelites Wrestling with the Giant Snakes* (plate 7; fig. 12). Van Mander mentioned this painting in his *Schilderboek* while valorizing his friend Cornelis, one of the most important artists of the late sixteenth and early seventeenth centuries.[60] An exquisitely executed reproductive engraving (plate 8) by Hendrick Goltzius of this tour de force of violence expressed in an imaginative composition further spread Cornelis's fame, and also helped to circulate a Michelangelesque pictorial idiom.[61]

Each of the engravings designed by Cornelis and executed by Goltzius and known collectively as the *Four Disgracers* (plates 9–12) features a lone, muscular figure falling through pictorial space. This focus on single figures is paramount: Each image becomes a physiognomic and pictorial experiment in exaggerated limb positions and twisted torsos. More so, they showcase Goltzius's ability to render, through engraved lines, rippling muscles that both strain against the bodily contortions and relax against the weightless free fall. The artists also demonstrated complete mastery of foreshortening and other pictorial tools, as the figures appear at different angles, requiring perspectival rendering of each part of their bodies.

The iconography of the *Four Disgracers* is also highly relevant for *Prometheus Bound*. In the prints,

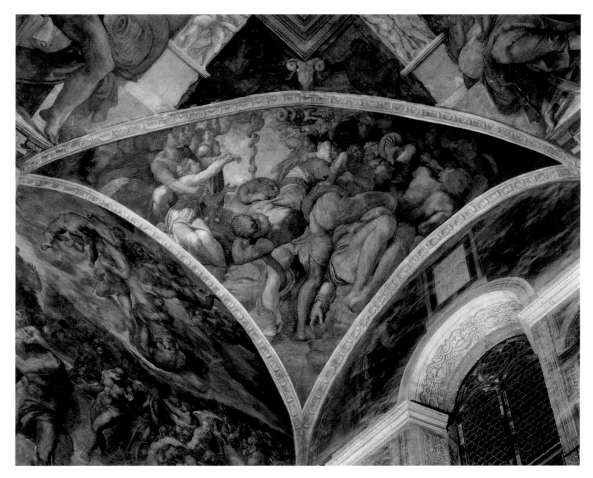

Tantalus, Icarus, Phaeton, and Ixion endure their fate. As a group, they harken back to the ensemble of which Titian's *Tityus* was a part. As Falomir has recently explored, *Tityus* was originally one of four paintings, alongside *Tantalus*, *Sisyphus*, and *Ixion*.[62] Since the ancient writer Homer, these four characters formed the "Disgracers," a group of sinners who ungratefully defied the gods and consequently received eternal punishment in Hades. Tityus attempted to rape Leto, so he had his ever-regenerating liver eaten by a vulture. For a lifetime of cunning and deceit, Sisyphus had to roll a boulder up a hill only to see it roll back down so that he had to begin anew. Tantalus murdered his son and thus was sentenced to stand in a body of water that receded each time he tried to drink. Ixion murdered his father-in-law and attempted to seduce Zeus's wife Hera, so he was bound to a fiery wheel that spun forever. Unusually, Cornelis and Goltzius swapped

Sisyphus and Tityus for Icarus and Phaeton. Icarus, of course, failed to heed his father's advice and flew too close to the sun, causing his wax wings to melt and plunging him to his death. Phaeton attempted to drive his father Apollo's sun chariot across the sky, but was unable to control the horses and thus fell to his death. This change shifted the group's composition from those rightfully punished for horrid crimes to those who suffered from excessive ambition and hubris. As will be explored in depth in chapter 3, the subject of Prometheus, who stole fire from the gods to give to humanity, aligns more closely with Cornelis and Goltzius's formulation than with that of the four sinners pictured by Titian.

Tityus was not among the *Four Disgracers*, but Goltzius depicted him in a painting of 1613 (fig. 13). A year earlier, Dominicus Baudius had composed a laudatory poem about Rubens's *Prometheus Bound*, which has led some scholars to

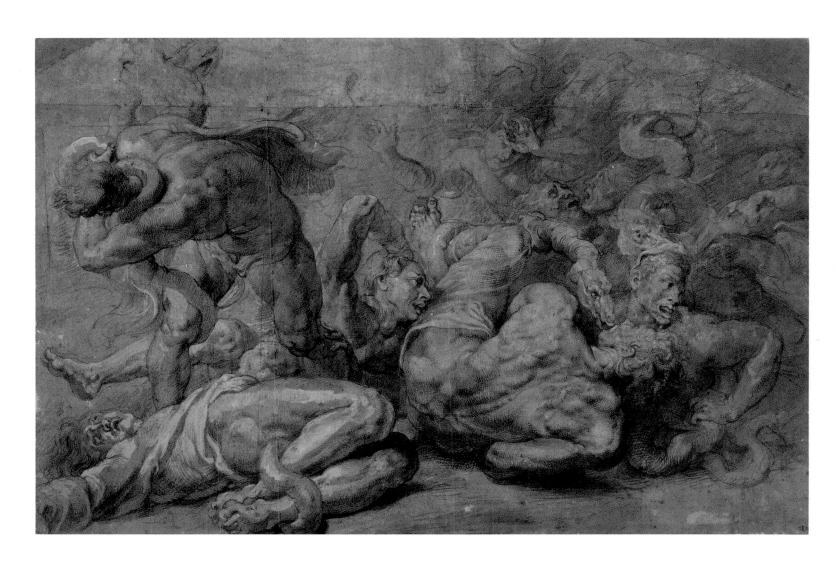

Plate 7
PETER PAUL RUBENS
after **MICHELANGELO BUONARROTI**
Israelites Wrestling with the Giant Snakes
c. 1607
Black chalk, pen and brown ink, brown and gray wash heightened with white on buff prepared paper, heavily cut and made up in various places
15⅛ × 23⁷⁄₁₆ inches (38.4 × 59.6 cm)
The British Museum, London

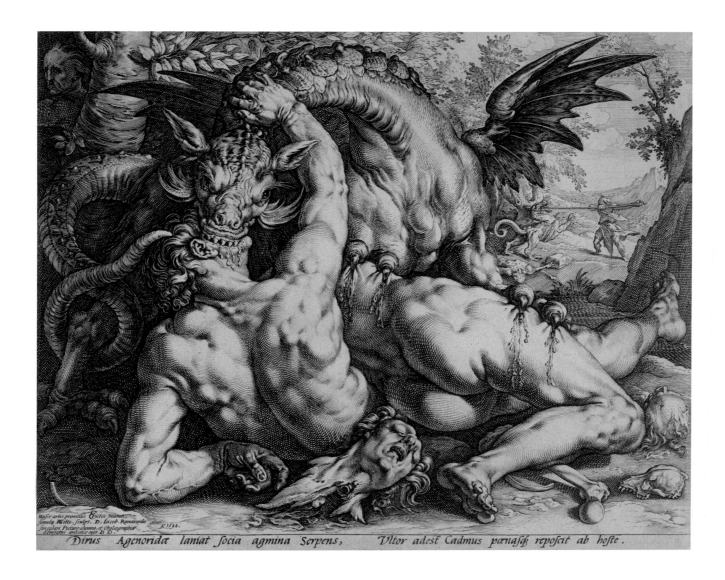

Hasce artis primitias Goltor sculpsit,
simulq Nicolæ sculpt. D. Iacob. Razoverde
singulari Pictor. obsemæ et Chalcographiæ
Æamitator amicitiæ ergo D.D.

A°1588.

Dirus Agenoridæ laniat socia agmina Serpens, Vltor adest Cadmus pænasq reposcit ab hoste.

Plate 8

HENDRICK GOLTZIUS

(Dutch, 1558–1617)

after **CORNELIS CORNELISZ. VAN HAARLEM**

(Dutch, 1562–1638)

The Dragon Devouring the Comrades of Cadmus

1588

Engraving

Sheet: 9⅞ × 12⅜ inches

(25.1 × 31.5 cm)

Philadelphia Museum of Art. The Muriel and
Philip Berman Gift, acquired from the John S.
Phillips bequest of 1876 to the Pennsylvania
Academy of the Fine Arts, 1985-52-1450

Plates 9–12

HENDRICK GOLTZIUS after **CORNELIS
CORNELISZ. VAN HAARLEM**

The Four Disgracers

1588

Engravings

Clockwise from top left:

Tantalus

Plate (round): 13⅛ × 13⅛ inches (33.4 × 33.4 cm)

Philadelphia Museum of Art. The Muriel and
Philip Berman Gift, acquired from the John S.
Phillips bequest of 1876 to the Pennsylvania
Academy of the Fine Arts, 1985-52-1445

Icarus

Plate (round): 13⅛ × 13⅛ inches (33.3 × 33.3 cm)

Philadelphia Museum of Art. The Muriel and
Philip Berman Gift, acquired from the John S.
Phillips bequest of 1876 to the Pennsylvania
Academy of the Fine Arts, 1985-52-1447

Ixion

Plate (round): 13¾ × 13¾ inches (34.9 × 34.9 cm)

Philadelphia Museum of Art. The Charles M.
Lea Collection, 1928-42-1610

Phaeton

Plate (round): 13⅝ × 13⅝ inches (34.6 × 34.6 cm)

Philadelphia Museum of Art. The Charles M.
Lea Collection, 1928-42-1609

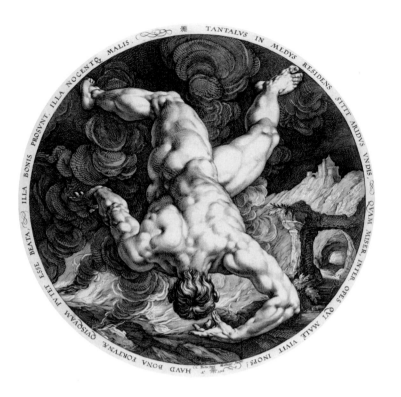

TANTALVS IN MEDYS RESIDENS SITIT ARIDVS VNDIS.

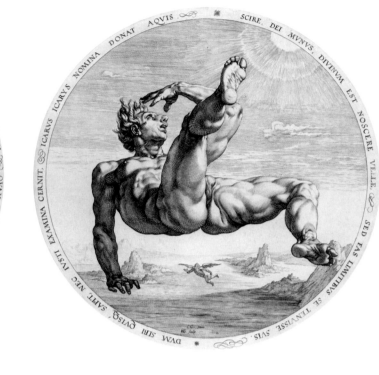

ICARVS ICARYS NOMINA DONAT AQVIS. SCIRE. DEI MVNVS, DIVINVM EST NOSCERE VELLE.

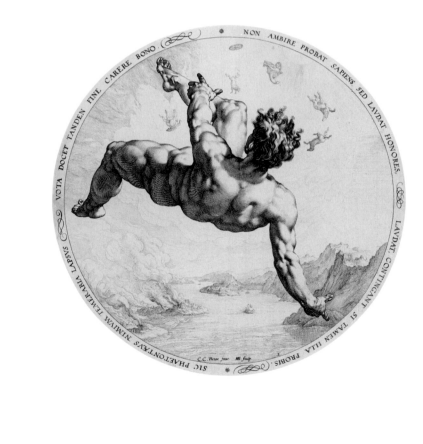

NON AMBIRE PROBAT SAPIENS SED LAVDAT HONORES.

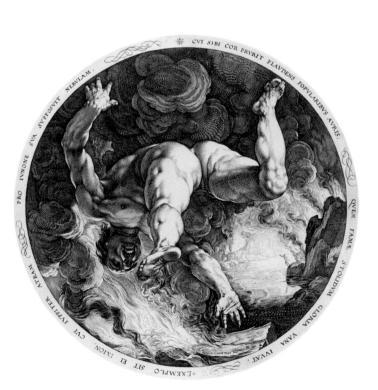

CVI SIBI COR PRVRIT FLAVDENS POPVLARIBVS AVRIS.

Fig. 13. Hendrick Goltzius. *Tityus*, 1613. Oil on canvas, 49¼ × 41⅜ inches (125 × 105 cm). Frans Halsmuseum, Haarlem

conclude that Goltzius followed Rubens's lead in depicting a tortured hero being attacked by a large bird.⁶³ It is not clear, however, if Goltzius actually saw Rubens's painting, or if he only knew of it indirectly from a source such as Baudius's poem. As far as we know, Goltzius did not travel to Antwerp after 1600, and Rubens's painting did not arrive in the northern Netherlands until 1618, when Rubens sent it to Carleton in The Hague. Rubens met Goltzius in Haarlem in 1612, so perhaps they could have discussed their shared interests at that point. In any event, Goltzius's painting has little to do with Rubens's composition. Indeed, in its horizontal rather than diagonal orientation, the relative scale of the bird of prey, and even the

victim's facial hair, Goltzius's picture is much closer to Titian's example, which he could have known through Cort's reproductive engraving (see fig. 2). That both Goltzius and Rubens turned to related subjects at almost the same time, as they did on at least six other occasions before Goltzius died in 1617, suggests a certain philosophical and aesthetic affinity between the two artists.⁶⁴ As Filip Vermeylen and Karolien de Clippel have posited, it seems that Rubens gained as much from his contact with Goltzius as the latter did from Rubens.⁶⁵

It seems likely that Rubens had at least begun *Prometheus Bound* before his 1612 trip to Haarlem. Since his return to Antwerp from Italy in 1609, he had become more deeply engaged with the art of

Michelangelo.[66] Rubens made his drawings after Michelangelo while in Italy, but few of his paintings from that period clearly relay the Renaissance master's influence. Rather, in works such as his 1608 altarpiece for Santa Maria in Vallicella in Rome (fig. 14), Rubens opted for a heavenly accompaniment of serene, fully dressed angels and playful, nude *putti* that in tone, style, and composition accord with the manner of his contemporary Annibale Carracci. With his return to the north in the 1610s, however, as will be addressed more fully in the next chapter, Rubens executed *Prometheus Bound*, as well as *Juno and Argus* (see fig. 18), the famous altarpieces *Raising of the Cross* (see fig. 19) and *Descent from the Cross* for the Antwerp cathedral, and the monumental *Great Last Judgment* (see fig. 20), all of which appropriate Michelangelo's hulking, nude males and the horrific physical conditions they are made to endure. It is possible that Rubens sought to assert his knowledge of Italian art to his northern European audiences. This would correlate to the artist's decision to build an Italian-style villa as his urban residence in Antwerp.

In engaging with Michelangelo, Rubens was participating in an existing aesthetic discourse, rather than initiating one. Although the Florentine artist died in 1564, nearly a half-century before Rubens began *Prometheus Bound*, he would still have been considered a modern master by Rubens's audiences. Van Mander's praise of Michelangelo in his *Schilderboek* helped bring the Italian painter and his aesthetics to the attention of Dutch-speaking audiences in the first decade of the seventeenth century.[67] Northern artists from Coxcie to Floris, Goltzius, and Rubens himself, furthered this trend by appropriating elements of Michelangelo's art in their own compositions.

SYNTHESIS OF STYLES

Though Rubens looked to an exceedingly wide array of artists for inspiration, he did not adopt an overall style from any single source. Rather, he synthesized diverse elements to arrive at a distinc-

tive artistic voice. In *Prometheus Bound*, Rubens melded a massive heroic male nude from Michelangelo with the evocative coloring and atmosphere of Titian, and to these added the downward diagonal placement of a fallen victim and the figural contortion common to much recent northern European art. Through this synthesis Rubens created the idiom that has come to define much of the Baroque aesthetic.

Pictorial synthesis was a key concept in early seventeenth-century aesthetics. The theory of synthesis in creative practice dates to antiquity and is perhaps stated most succinctly by the first-century Roman writer Quintilian:

To produce a perfect and complete copy of any chosen author, we shall do well to keep a number of different excellencies before our eyes, so that different qualities from different authors may impress themselves on our minds, to be adopted for use in the place that becomes them best. . . . Even great authors have their blemishes, for which they have been censured by competent critics and have even reproached each other.[68]

As Jeffrey Muller has explored in his essay on Rubens's practice of artistic emulation, Quintilian's formulation of synthesis was applied to the visual arts by the Italian theorist Giovanni Battista Agucchi.[69] In his *Trattato della pittura* (Treatise on pictures) of 1607–15, Agucchi argued that Annibale Carracci achieved the ideal by synthesizing the Florentine-Roman concept of *disegno* with the Venetian style of *colore*.[70] Pictorial synthesis, especially of Michelangelo's *disegno* with Titian's *colore*, was thus a "critical strategy" in Italian Baroque practice and theory, as Maria Loh has recently argued.[71] Moreover, application of this strategy was centered in Rome. For example, in 1595 Annibale relocated from Bologna to Rome, where he painted many pictures and frescos that epitomize the synthesis praised by Agucchi, Carlo Cesare Malvasia, and others. Agucchi himself lived and worked in Rome from 1594 to 1623.

After several years of service to the Duke of Mantua, Rubens moved to Rome in 1606–8

Fig. 14. Peter Paul Rubens. *Virgin and Child with Angels*, 1606. Oil on slate, 13 feet 9 inches × 8 feet 2 inches (4.3 × 2.5 m). Santa Maria in Vallicella, Rome

because it was the capital of the art world, not only in Italy, but perhaps in all of Europe. From the artist's correspondence, we know that Rubens very much wished to make a name for himself there. Upon receiving the commission to paint the altarpiece for Santa Maria in Vallicella in 1606, he wrote:

When the finest and most splendid opportunity in all Rome presented itself, my ambition urged me to avail myself of the chance. It is the high altar of the new church of the Priests of the Oratory, called Sta. Maria in Vallicella—without doubt the most celebrated and frequented church in Rome today, situated right in the center of the city, and to be adorned by the combined efforts of all the most able painters in Italy. . . . No one is more capable of making the Lord the Duke understand how great my interest is, in the honor as well as the profit.[72]

In winning this competitive commission for a prestigious and highly visible site, Rubens clearly sought to extend his reputation in Rome. To do so, he needed to produce a thoroughly modern work of art, which he did by emulating Annibale's synthetic mode. Put differently, though a Fleming by birth, to succeed in the world of contemporary Roman art Rubens had to paint like a local. As the altarpiece in Santa Maria in Vallicella illustrates, this meant painting in an Annibale-inspired fashion. Moreover, this was Rubens's way of thinking and working right before he returned to Antwerp and began *Prometheus Bound*.

Rubens's comprehensive synthesis of forms and styles was enabled by his extensive travels, which had allowed him to see Titian's *Tityus* and Coxcie's *Death of Abel* in Madrid, Michelangelo's *Tityus* and Sistine *Last Judgment* as well as the Laocoön in Rome, works by Floris in Antwerp, and the art of Cornelis and Goltzius in Haarlem. The prints that no doubt impacted Rubens's artistic vision could be procured both at home and abroad, but the painted and drawn works that inspired him required long journeys. Few, if any, artists of the day covered as much territory as did Rubens, who is known to have visited at least fifty European cities. In this way, Rubens was a citizen of Europe. One can say the same for his art. By synthesizing such a diverse range of sources, Rubens forged a new aesthetic that was international in scope and stature, yet also entirely his own.

2 | HORROR AND PHYSICALITY

FOR ALL ITS AESTHETIC QUALITIES, *Prometheus Bound* (see plate 1) is a raw, gruesome picture. The hero lies prone as an eagle rips his liver from his chest with a razor-sharp scimitar of a beak. To gain a better purchase, the eagle digs its talons into the victim's abdomen and skull. Chained to the rock, Prometheus cannot escape his assailant, but he appears to strain against the attack, kicking his legs and clenching his fist. His bonds are so tight that much of the color has fled his left wrist and hand, leaving them ghoulishly gray. Prometheus's face registers horror and helplessness at the attack and his inability to defend himself (fig. 15). His left eye is locked on the bird's head and the gaping wound in his own chest.

Rubens heightened the impact of this visceral attack by emphasizing Prometheus's massive, barrel-chested form. The nude figure's muscles bulge and ripple as he strains against his attacker and the bonds that restrain him. Seemingly every fiber bristles with power, from his flexed toes to his tight neck. This treatment meshes perfectly with the ancient myth. Gigantic, immortal, and immeasurably strong, Prometheus was one of the Titans, the first generation of Greek gods and goddesses who ruled until being overthrown by the Olympians, led by Zeus. Rubens conveyed Prometheus's size by working on a large scale. The painting is nearly eight feet tall by seven feet wide, and the figure would be at least seven feet tall if placed on a vertical axis with legs straight. But Rubens has disempowered Prometheus by placing him upside down.[1] The figure has lost so much control that he cannot keep his head upright. This is disconcerting and discomforting for viewers. That an individual of Prometheus's size and strength could fall victim to such bodily pain amplifies the energy of the painting. Likewise, the clear physical strength of Prometheus magnifies the gruesomeness of the attack he is forced to endure.

The earliest recorded response to Rubens's *Prometheus Bound*—a poem written in 1612 by Dominicus Baudius, a professor at the University of Leiden—emphasizes its horrific qualities:

Here, with hooked beak, a monstrous vulture digs about in the liver of Prometheus, who is given no peace from his torments as ever and again the savage bird draws near his self-renewing breast and attacks it punishingly. He is not content with his inhuman sacrificial feast, but with claws lacerates, here the agonized face, there the man's thigh. He would fly murderously on his spectators, did not his chained prey detain him. He can do no more than terrify frightened onlookers by turning his flaming eyes from one to the other. Blood flows from the chest and every part where his claws leave their mark, and his piercing eyes dart savage flames. You might think that he moves, that his feathers tremble. Horror grips the onlookers.[2]

Baudius vividly describes Prometheus's predicament and pain. Clearly, the poet was enraptured by Rubens's violent vision applied to this ideal physical specimen. Just as importantly, Baudius's final line signals how the painting compelled those who saw it to be gripped with horror.

Prometheus Bound is but one example of Rubens's deep interest in the 1610s in depicting torment and physical pain, often with related figural poses. Many of his subjects come from antiquity, but he was also occupied with the crucified Christ and the damned at the Last Judgment. Rubens's engagement with graphic subjects reflects the importance of such imagery in seventeenth-century aesthetics. His intermingling of secular and religious themes also places the artist within the Neostoic movement, a revival of the ancient philosophy embraced by scholars of Rubens's time, including his brother Philip.

Fig. 15. Detail of *Prometheus Bound* (see plate 1)

RUBENS AND HORROR

In the 1610s, upon his return to Antwerp from Italy, Rubens specialized in making horrific paintings. In contrast to the soft, fleshy female nudes set in atmospheric pastoral settings that he would craft in the early 1630s, Rubens in this period opted for violent scenes of male figures assaulted by all manner of physical torment. As discussed in the previous chapter, the artist's interests at this time can be traced to the art he had studied and absorbed while in Italy, especially Michelangelo's creations and the antique sculpture known as the Laocoön.

In paintings with mythological subjects, Rubens frequently addressed protagonists who faced extreme physical pain, if not death, and selected the most dramatic moment in the narrative to accentuate the macabre. Several paintings closely associated with *Prometheus Bound* exemplify this feature. In *The Fall of Phaeton* (fig. 16), which Rubens painted in 1604 or 1605 and then likely reworked between 1606 and 1608, the son of Apollo plummets to earth after his failed attempt to drive his father's sun chariot across the sky. Phaeton appears rather languid, but the overturned chariot and the horses flying furiously in all directions foreshadow the protagonist's impending lethal impact. Another such painting is *Death of Hippolytus* (fig. 17) of about 1611–13, in which the title character, falsely accused of rape by his stepmother, Phaedra, and cursed by his father, Theseus, is attacked by a sea creature sent by Poseidon. The painting depicts the moment that the creature rises from the water to frighten the horses. Hippolytus has been thrown from his chariot and is about to meet his end, trampled beneath the hooves of the powerful animals he once drove. A third example, *Juno and Argus* (fig. 18) from about 1610, features a dead male protagonist. Mercury has decapitated Argus, the giant hundred-eyed sentry, whose patron Juno is having her faithful servant's eyes plucked out and placed on the tail feathers of the sacred peacock. Though it pictures an act of homage, this is a brutal scene.

Fig. 16. Peter Paul Rubens. *The Fall of Phaeton*, c. 1604–5, probably reworked c. 1606–8. Oil on canvas, 38¾ × 51⅝ inches (98.4 × 131.2 cm). National Gallery of Art, Washington, DC

Fig. 17. Peter Paul Rubens. *The Death of Hippolytus*, c. 1611–13. Oil on copper, 19¾ × 27⅞ inches (50.2 × 70.8 cm). Fitzwilliam Museum, Cambridge

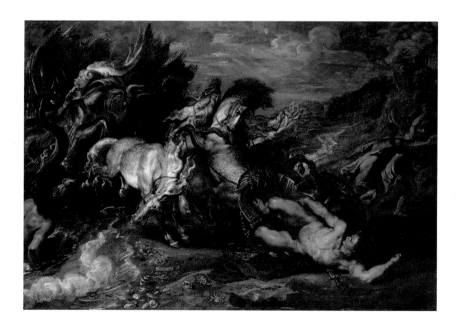

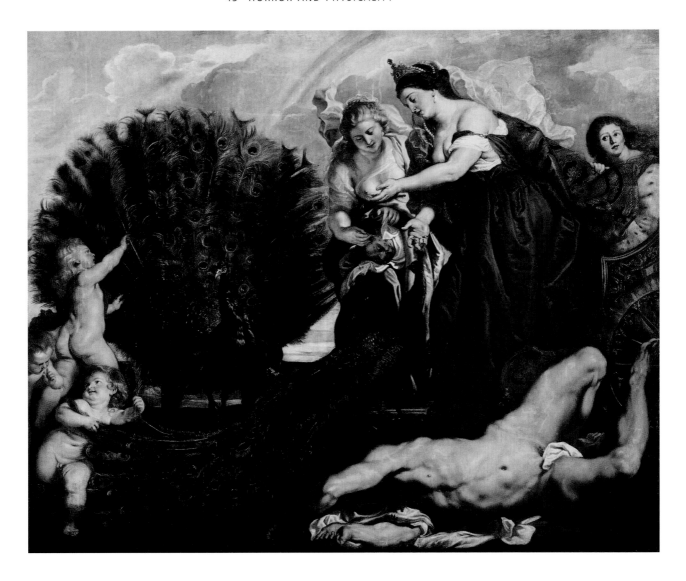

Argus's lifeless body lies on the ground as a hand-maiden cradles his severed head in her lap. She is in the process of plucking out one of Argus's eyes, while Juno holds several more eyes in her outstretched hands. Importantly, the artist used almost the exact same figural pose for his depictions of Prometheus, Phaeton, Hippolytus, and Argus. For Rubens, this pose must have seemed particularly apt for conveying physical anguish.

Many of Rubens's religious paintings from the 1610s and early 1620s created in Antwerp also share a violent bent. Most famously, his great altarpieces for the Church of Our Lady in Antwerp—the *Raising of the Cross* of 1610–11 (fig. 19)

and the *Descent from the Cross* of 1611–14 (see plate 4)—focus on Jesus during and after his torture. In the former, Christ faces his fate with blood flowing from the wounds on his hands, feet, and head. In the latter, his lifeless body is bloody, bruised, and beaten from all that he has endured. More diffusely, *The Great Last Judgment* of 1617 (fig. 20) and *The Fall of the Damned* of 1621 (both now in the Alte Pinakothek, Munich) are littered with figures attacked, mangled, and devoured by all manner of demons and nightmarish beasts.

Images of physical distress appear occasionally in Rubens's later works. In the tapestry *Triumph of Constantine over Maxentius at the Battle of the*

Fig. 18. Peter Paul Rubens. *Juno and Argus*, c. 1610. Oil on canvas, 8 feet 2 inches × 9 feet 9 inches (2.5 × 3 m). Wallraf-Richartz Museum and Fondation Corboud, Cologne

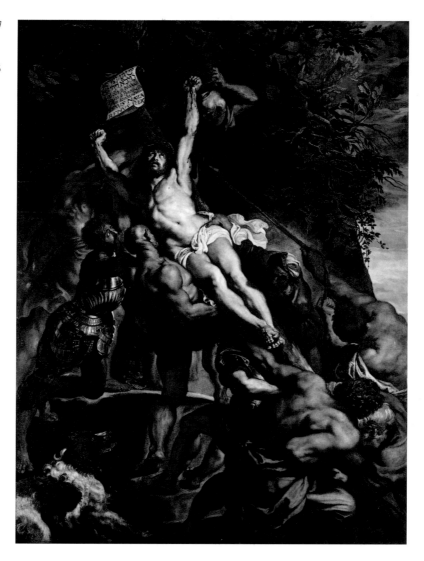

Fig. 19. Peter Paul Rubens. *Raising of the Cross* (center panel of altarpiece), 1610–11. Oil on panel, 15 feet 1 inch × 11 feet 2 inches (4.6 × 3.4 m). Church of Our Lady, Antwerp

Milvian Bridge (fig. 21), from the Life of Constantine series of the mid-1620s, viewers encounter a swirling storm of figures, including an upturned man at bottom center who is not dissimilar to those in Michiel Coxcie's *Death of Abel* (see plate 5) and the sixteenth-century Flemish prints (see plate 6; fig. 2) that had inspired the composition of *Prometheus Bound*. Perhaps even closer to Prometheus in its dramatically diagonal placement is the figure that appears in the mouth of the monster at lower left in Rubens's *Franciscan Allegory in Honor of the Immaculate Conception* from 1631–32 (plate 13). In both examples, the artist reworked his earlier prototype for the figures through which he sought to communicate tumultuous upheaval. They further

suggest that Rubens continued to see a sprawling, upended character as an appropriate, if not ideal, figural expression of pain, torment, and horror.

In aesthetic terms, the pictorial expression of horror may be understood through the concept of *terribilità*. As David Summers has documented, this term appeared repeatedly in sixteenth-century Italian art criticism.[3] Rather than translating from the Latin literally as "terrible," *terribilità* connoted grandeur, force of expression, artifice, and skill. It was also a qualitative term that signified greatness. *Terribilità* conveyed the forcefulness, physicality, and power of the work of art, and of the artist who made it.

The artist most often associated with *terribilità* was Michelangelo. Giorgio Vasari, for example,

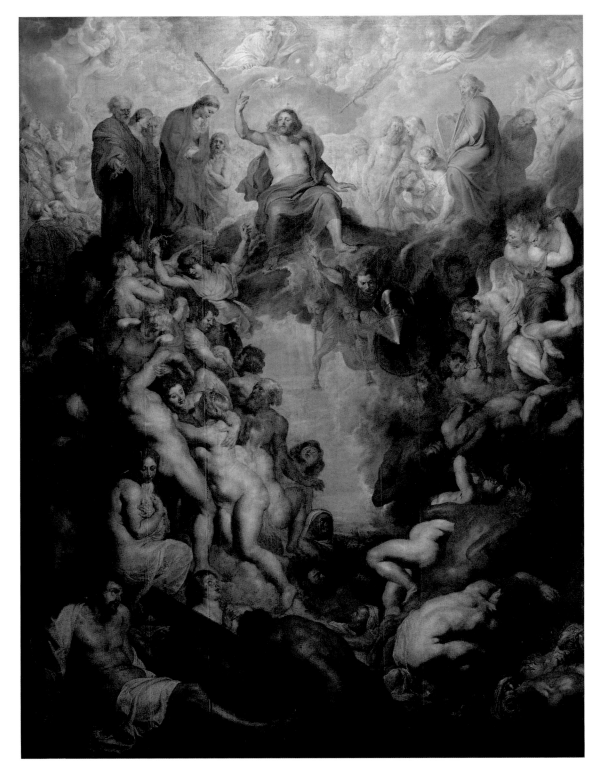

Fig. 20. Peter Paul Rubens. *The Great Last Judgment*, 1617. Oil on canvas, 20 feet × 15 feet 3 inches (6.1 × 4.6 m). Alte Pinakothek, Munich

Fig. 21. Designed in 1622 by Peter Paul Rubens; woven at the Comans–La Planche tapestry factory, Paris. *Triumph of Constantine over Maxentius at the Battle of the Milvian Bridge,* 1623–25. Wool and silk with gold and silver threads, 15 feet 11 inches × 24 feet 5 inches (4.9 × 7.4 m). Philadelphia Museum of Art. Gift of the Samuel H. Kress Foundation, 1959-78-3

described the Sistine *Last Judgment* (fig. 22) as follows: "There is a certain variety and terrible force [*terribilità*] in the attitudes and groups of those nudes that are raining down from Heaven, and of the others who, having fallen into the center of the earth, are changed into various forms of Devils, very horrible and bizarre."[4] Indeed, while works such as Michelangelo's sculpture *Moses* (c. 1513–15; San Pietro in Vincoli, Rome) also earned the designation, the Sistine *Last Judgment* was perceived as most fully embodying *terribilità*. As Vasari noted, it was the chaotic accumulation of contorted bodies that inspired this reaction. In their sprawling gymnastics and almost total

nudity, as well as the artist's masterful rendering of volumes, these figures exert a physical presence. Here, *terribilità* is experienced as a physical phenomenon writ on a massive scale: the viewer standing in the chapel encounters a monumental scene, almost forty-five by forty feet, with nearly two hundred figures enveloping his or her field of vision.[5]

Thomas Puttfarken has argued that Titian also exhibited *terribilità*.[6] In *Tityus* (see plate 2), for example, he crafted an enormous picture of a gruesome subject that, like the Sistine *Last Judgment*, fills the viewer's field of vision. The sense of awe created by this dramatic rendering of the giant

Plate 13

PETER PAUL RUBENS

Franciscan Allegory in Honor of the Immaculate Conception

1631–32

Oil on panel

21⅛ × 30⅞ inches

(53.7 × 78.4 cm)

Philadelphia Museum of Art.

John G. Johnson Collection, 1917,

cat. 677

being disemboweled is magnified by the scale of the painting. Titian's brooding color scheme and bold application of paint create a sense of grit and verve that works in tandem with the other elements to forge what in Renaissance aesthetics is truly a "terrible" painting.

The Laocoön (see fig. 5), from which Michelangelo, Titian, and Rubens all derived inspiration, was perhaps the most horrific exploration of pain and suffering then known. The first-century sculptors Agesandros, Polydoros, and Athenodoros selected the most graphic and charged moment in Virgil's narrative, as the priest and his sons attempt to fight off the enormous snakes that entwine their bodies and constrict around their ankles, thighs, and shoulders, while one serpent sinks its fangs into the priest's hip. It is the figures' struggle against their serpentine foe that creates the sense of dread, as Laocoön in particular marshals every fiber of strength in his body to try to hold off the assault. The wrinkled brow, the downturned eyebrows, and the ripples of creases that populate the expanses of his cheeks forge an expression of pain and suffering. In total, the sculptors created an excruciating image of a thoroughly violent story.

From the moment of its rediscovery in 1506, the Laocoön was noted for the horror it depicted.[7] The best-known description, penned that same year, is by the poet Jacopo Sadoleto:

Scarce can the eyes endure to look upon
The dreadful death, the cruel tragedy . . .
By keen pain goaded and the serpent's bite,
Laocoon groans, and struggling from his side
To pluck the cruel teeth, in agony . . .
We all but hear the groans[8]

Sadoleto continues by describing the horror of one of Laocoön's sons:

His father's anguish seen he stands aghast,
Transfixed with horror—his loud wailings stay,
His falling teardrops stay—in double dread.[9]

Like others who followed, Sadoleto described not only the sculpture, but also the experience of viewing the group, which evoked physical and psychological pain. Maria Loh notes that responses to the Laocoön are littered with declarations of the intense emotions, horror, and even screams it elicited from viewers in the sixteenth and early seventeenth centuries.[10]

Following Aby Warburg, L. D. Ettlinger influentially postulated that the Laocoön, in its figural composition and facial expressions, became a model for artists wanting to represent life-or-death struggle.[11] The Italian painter and theorist Giovanni Paolo Lomazzo, in his 1585 *Trattato dell'arte della pittura, scoltura et architettura* (Treatise on the arts of painting, sculpture, and architecture), referred to the Laocoön as the ultimate visualization of *dolore*—felt pain:

Since I have spoken of Expression in general, and in particular of the natural and accidental expressions of the body, which proceed from the soul as from motive causes, there remains in this place to add the particular expression of the passions and accidental apprehensions, which could not be treated under the rules established for the others. And these are not less necessary than the others for anyone who desires to proceed according to reason in his painting, and to imitate the truth in nature, both as his model and as his example. The first passion then is *Dolore*, according to which the torment of one so afflicted makes his body move in an anguished way. It was this sort of thing which Achilles Tatius was describing in the person of Prometheus tied to the rock with the vulture pecking at his liver, when he said that he drew back his belly and his rib cage, and to his own harm pulled up his thigh. For this only led the bird closer to his liver, and at this encounter he extended out his other foot with the veins standing up even into the extremity of his toes, and also showed anguish in the other parts of his body with the arching of his eyebrows, the tightening of his lips, and the showing of his teeth. Beyond this, *Dolore* can be shown by contorting the body at the diverse joints, and by rolling the eyes in the way one does when poisoned, or when bitten by a snake. This kind of thing was excellently expressed by the three ancient Rhodian masters

Fig. 22. Michelangelo Buonarroti. *Last Judgment*, 1536–41. Fresco. Sistine Chapel, Vatican Palace, Vatican

Agesandros, Polydoros, and Athenodoros in the highly celebrated statue of Laocoon and his sons, in which one figure is seen in the act of anguish, another in the act of dying, and the third in having compassion; and this can be seen nowadays in the Belvedere in Rome.[12]

Lomazzo links the Laocoön to the subject of Prometheus, seeing the latter's punishment as the ultimate tale of physical anguish, while the Laocoön was the premier visualization of it. More specifically, he directs readers to Achilles Tatius's description of a lost painting of Prometheus by Euanthes, which the ancient writer described in sufficient detail for one to imagine what it must have looked like. Charles Dempsey argues that Lomazzo's discussion of *dolore* issued an artistic challenge: the ultimate image of anguish would be one of Prometheus that drew upon the forms and expression of the Laocoön.[13] Rubens almost certainly would have known of Lomazzo's challenge, and it may even have inspired Rubens to paint Prometheus, or at least influenced the way he chose to depict the Titan.[14]

Rubens's penchant for painting graphic violence can thus be understood as an aesthetic decision. Horrific scenes have a considerable place in the history of art. Furthermore, such images were revered in Rubens's time, and were in many ways associated with his prime inspirations—Michelangelo, Titian, and the Laocoön.[15] The expression of physical pain was a valued pictorial mode, and it may have provided Rubens with a means to further align his works and his identity with the greatest masters of the recent and ancient past.

NEOSTOIC SUFFERING

For Rubens the visualization of horror, especially that found in *Prometheus Bound*, was also a means to convey the Neostoic ideal of self-control in the face of suffering. His painting *The Four Philosophers* (fig. 23) of around 1611–12 demonstrates the artist's personal allegiance to Neostoicism, a movement based largely on the writings of the first-century Roman philosopher, dramatist, and

statesman Seneca. A sculpted bust then thought to portray Seneca stands in the niche on the right of the painting.[16] Seated at the book-strewn table below and wearing a fur-trimmed cloak is Justus Lipsius, the scholar whose writings revived Stoic philosophy in the late sixteenth and early seventeenth centuries.[17] Students of Lipsius flank him on both sides: on the right is Jan van der Wouwer, financial counselor to the governor of the Spanish Netherlands; on the left is the artist's brother, Philip Rubens, who was librarian of the Colonna family in Rome and a humanist scholar in his own right. Lipsius gestures to his former pupils while pointing to a passage in the text before him. By placing them below the bust of Seneca, Rubens implies that the conversation is inspired by the ancient Roman's words. Rubens painted himself into the scene, standing to the left and observing, if not actively participating. By doing so, he aligns himself with the group, the writings they discuss, and the Stoic philosophy they practiced. This image is consistent with what we know of the artist's personal inclinations. For example, Rubens decorated the arched gateway to the courtyard of his house in Antwerp with quotations from the Stoic poet Juvenal.

A central tenet of Neostoicism was constancy, a concept that included maintaining self-control while enduring suffering. In the second book of his *De constantia* (On constancy; published 1584, reprinted 1605), Lipsius wrote:

Constancy I here designate an upright and unmoved vigor of mind that is neither uplifted nor cast down by outward or chance occurrences. . . . The true mother of Constancy is Patience . . . which I define as the willing endurance without complaint of whatever occurs or befalls a man from without.[18]

Constancy and patience would serve to counter the violence of the world.[19] Wolfgang Brassat has termed this the "stoic contrast."[20] Indeed, Stoic and Neostoic writings often centered on violence, both physical and conceptual. Seneca's writings

Fig. 23. Peter Paul Rubens, *The Four Philosophers*, 1611–12. Oil on canvas, 64⅝ × 54¾ inches (164 × 139 cm). Galleria Palatina, Palazzo Pitti, Florence

are filled with explicitly violent scenes, and his plays such as *Hercules furens*, with all their graphic gore and terror, were regularly staged in northern Europe in the early seventeenth century.[21] Lipsius himself lived in a violent age, beginning his treatise amid the political, religious, and social upheaval in the Netherlands following the iconoclastic outbreaks of the 1560s, and completing it just before the Dutch revolt against Spanish rule led to twenty years of war. Suffering and violence were rampant for Lipsius and those in his milieu, including Rubens.

No subject or character from antiquity epitomizes constancy in the face of suffering better than Prometheus. Chained to Mount Caucasus, Prometheus is attacked by an eagle, who shreds his abdomen and eats his regenerating liver. Some ancient sources say that this cycle of attack and healing repeated every day for several centuries, until Hercules shot the eagle with an arrow and broke the Titan's bonds (plate 14). Not surprisingly, Stoics and Neostoics alike invoked the Titan in their writings on how to maintain emotional control in the face of physical and psychological adversity. Cicero, for example, cast Prometheus as a heroic *exemplum* of endurance.[22] Closer to Rubens, Lipsius linked his concept of constancy to the story of Prometheus. In a dialogue he con-

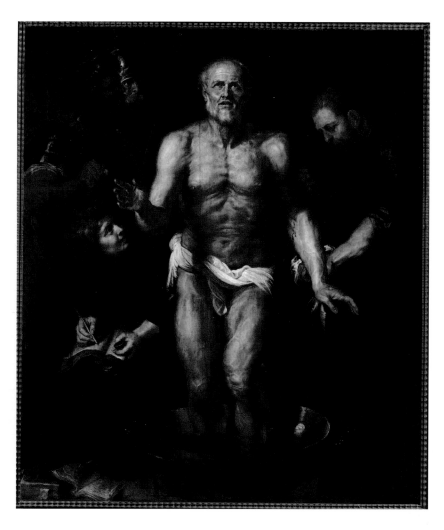

Fig. 24. Peter Paul Rubens. *The Death of Seneca*, c. 1612–13. Oil on panel, 72⅞ × 60⅞ inches (185 × 154.7 cm). Alte Pinakothek, Munich

Take, for example, the artist's choice of narrative moment. The myth of Prometheus is a rich one (see chapter 3), but rather than presenting Prometheus stealing fire, being chained to the mountain, or being released from captivity, Rubens instead selected the agonizing moment when the eagle rips his liver from his abdomen. His body registers the assault—his legs flail, his muscles tense—but despite his pain and torment Prometheus remains relatively calm. His lips part, but he does not scream. His eyes are wide, but they are locked and focused. Prometheus remains in control of his emotions. Just as "stoic contrast" defined suffering in relation to worldly violence, Rubens gave equal treatment to sufferer and assailant. Indeed, eagle and Titan are the same size and are positioned almost as diagonal mirror images, or foils for each other. Perhaps even the collaboration between Rubens and Frans Snyders, in which Rubens painted the figure and Snyders the bird, plays into this formulation of complementary elements.

The virtues of patience, acceptance of authority, and submission to divine judgment were integral components of Neostoic attempts to reconcile the writings of Seneca and others with Christianity. As early as the second century, supporters argued that Senecan moral philosophy was compatible with Christian ethics.[24] The Neostoics took this idea further, presenting the Roman philosopher as a sort of proto-Christian. Consider, for example, Rubens's own painting of *The Death of Seneca* from about 1612–13 (fig. 24), in which, as Mark Morford has shown, the Stoic resembles a Christian martyr.[25] In keeping with a long tradition of depicting heroic figures valiantly facing torture, Rubens illustrates how Seneca, after being unjustly sentenced to commit suicide by the emperor Nero, severed his own arteries and bled to death. Though figures from antiquity were commonly painted nude, Rubens has wrapped Seneca in a discreet loincloth to show his subject's virtue in typically Christian fashion. Moreover, Seneca's eyes are turned heavenward, like those in

structed between himself and his companion Langius, Lipsius wrote:

"I am reminded of my country; and public and private worries stick fast in my mind. You, if you can, drive off the wicked birds that are tearing me to pieces, and remove these chains of anxiety by which I am bound securely to this Caucasus."

Langius answered with a lively countenance, "I shall truly remove them and as a new Hercules I shall release this Prometheus. Only listen carefully and intently. I have called you to Constancy, Lipsius, and in it I have placed the hope and preservation of your well-being."[23]

In *Prometheus Bound*, Rubens has presented us with a portrayal of the hero that correlates precisely with the Neostoicism to which he adhered.

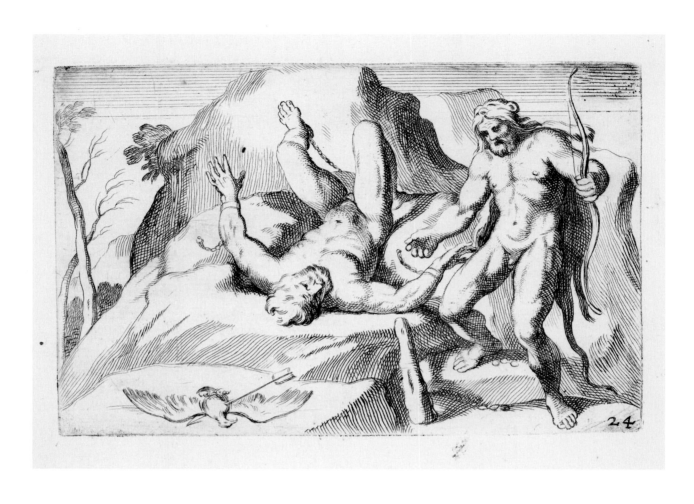

Plate 14
CARLO CESIO
(Italian, 1622–1682)
after **ANNIBALE CARRACCI**
(Italian, 1560–1609)
Hercules Liberating Prometheus
c. 1650s
Etching and engraving with
plate tone
Plate: 3⅝ × 6⅟₁₆ inches
(9.2 × 15.3 cm)
Philadelphia Museum of Art. The
Muriel and Philip Berman Gift,
acquired from the Pennsylvania
Academy of the Fine Arts,
1985-52-32189b

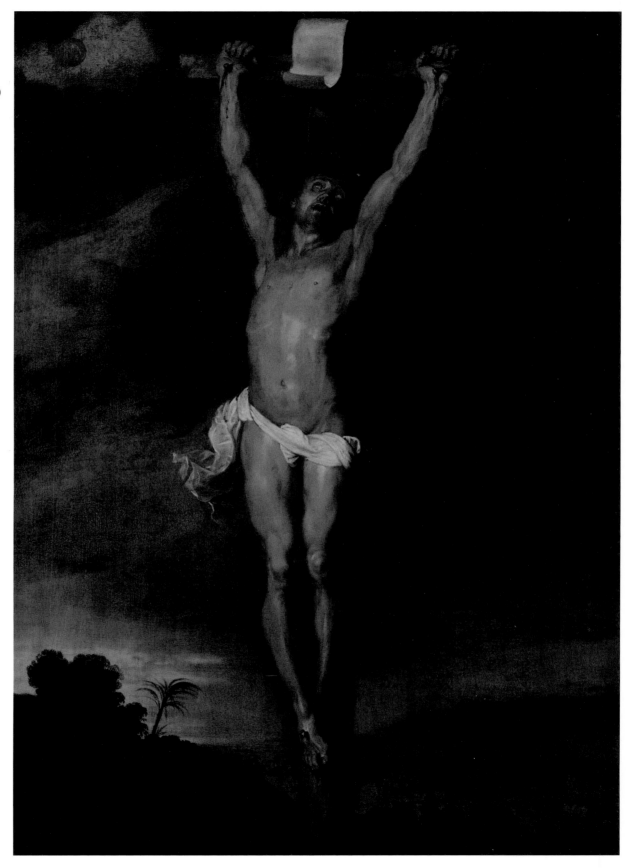

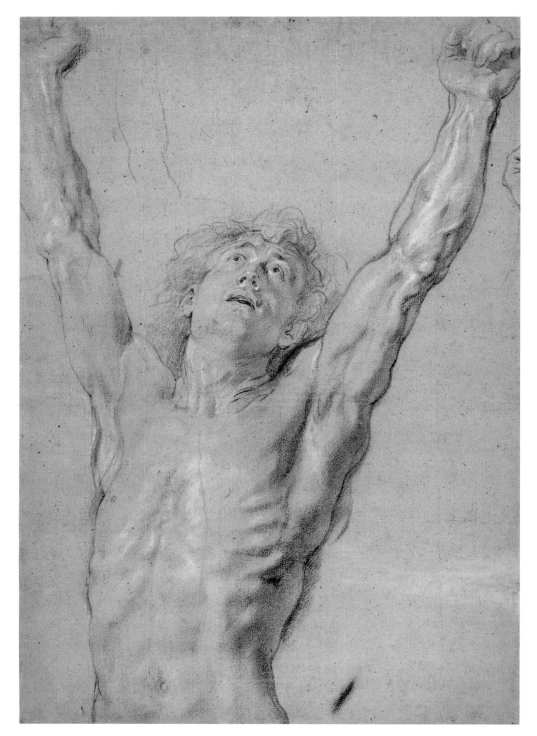

Plate 16

PETER PAUL RUBENS

Crucified Man

c. 1615

Black chalk on paper with
some brown wash,
heightened with white

20⁷⁄₁₆ × 14⁹⁄₁₆ inches
(52 × 37 cm)

The British Museum,
London

3 | CREATION, AMBITION, AND COLLABORATION

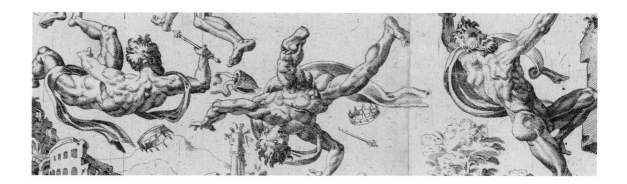

PROMETHEUS STANDS AS AN ICON of pain, punishment, and Stoic resolve—but this is only part of the meaning of this complicated character. The myth also centers on his role as a creator. Rubens enabled his painting of the subject to be read from this perspective by creating an allegory of artistic creation and ambition that, as an ambitious painting in its own right, in turn reveals the artist's aspirations. Rubens's collaboration with Frans Snyders furthered the painting's ambitious program—and offers another window through which to contemplate the struggles of creation it embodies.

PROMETHEUS AND CREATION

Aeschylus, in his trilogy of plays known as the *Promethia*, was the first to emphasize Prometheus's role as creator. Of the three, only *Prometheus Bound* exists in its entirety—the others, *Prometheus Unbound* and *Prometheus the Fire-Bringer*, are known in fragments. Even so, the play stands as the longest exposition on the myth from all of antiquity. Aeschylus's treatment deviates significantly from those of his predecessors, most of which present Prometheus as a comic or semi-comic character who is properly punished for his impudent attempts to trick Zeus. The earliest account, by Hesiod, mentions the motivation for stealing the fire only in passing. Aeschylus, by con-

trast, portrays Prometheus as a tragic hero. Chained to the rock on Mount Caucasus, the Titan laments his predicament:

> For the power, the glory I gave to human beings
> 	I'm bound in irons.
> I tracked down fire, where it springs from.
> And stole it. I hid
> 	the spark in a fennel stalk, and brought it
> to human beings. Now it shines
> 	forth: a teacher
> showing all mankind the way to all the arts there are.
> *That's* my crime. That's why
> I'm hammered in chains under the open sky.[1]

In Aeschylus's play, Prometheus provides human beings with the gift of fire that enables them to create for themselves. In this way, he provides the literal and metaphorical spark for human creativity.[2] In the versions of the story given by Menander and Philemon, the Titan also creates the first human being by fashioning a figure from clay and animating it with the stolen fire.[3]

Prometheus was not as common a subject in the visual arts of antiquity.[4] The first modern paintings dedicated to Prometheus seem to be Piero di Cosimo's pendant panels from about 1510 (figs. 25, 26), in which the Florentine artist presents most of the key moments in the Titan's story. From left in the Munich panel, Prometheus sculpts man, the fin-

Fig. 25. Piero di Cosimo (Italian, 1462–1521). *Episodes from the Myth of Prometheus*, c. 1510. Oil on panel, 26 × 46¾ inches (66 × 118.7 cm). Alte Pinakothek, Munich

Fig. 26. Piero di Cosimo. *Episodes from the Myth of Prometheus*, c. 1510. Oil on panel, 25³⁄₁₆ × 45¹¹⁄₁₆ inches (64 × 116 cm). Musée des Beaux Arts, Strasbourg

ished sculpture stands on a pedestal, and Athena lifts Prometheus into the sky. The story continues in the Strasbourg painting, which shows Prometheus infusing his sculpture with the stolen fire, the Olympian gods determining his punishment, and Hermes binding Prometheus to a tree. A giant eagle perches in the tree, ready to unleash its beak and talons on the now bare-chested Prometheus below. Piero omitted the portions of the narrative pertaining to Pandora, but otherwise presents a rather comprehensive visual account. In this regard, his paintings are anomalies.

While alluding to his punishment, the paintings by Piero devote far more space and attention to Prometheus's creative capabilities. Piero references not only Prometheus's punishment, but also the motivations for his actions. Interestingly, Piero did not paint the actual theft, but only the fire that Prometheus stole.[5] With only indirect reference to his crime, the viewer is perhaps guided to more lenient interpretations than are possible with Tityus. Or, the viewer is left to decide whether Prometheus's punishment was warranted, given his motivations.

A print by an unknown artist after a design by Hendrick Goltzius (plate 17) places even more

emphasis on Prometheus's role as a creator. Goltzius has eliminated all reference to Prometheus's punishment. Instead, the central scene shows the hero applying fire to the still-limp clay figure's chest just below the left pectoral muscle. Standing perfectly upright and wearing a luxurious flowing garment, Prometheus strikes an elegant figure. His well-groomed hair and beard imply a sense of gravitas. At top, guided by Athena, goddess of wisdom, Prometheus holds out his torch to procure fire from the wheels of the sun. In these ways, Goltzius valorizes Prometheus's generative actions.

Whether as animator or as spark of creativity, fire is the creative force that Prometheus gifts to humanity. It is fitting, then, that Rubens includes a lit torch in the bottom left-hand corner of his painting (see fig. 30). Dominicus Baudius makes no mention of the torch in his laudatory poem of 1612, which first identified the subject of Rubens's picture—perhaps indicating that the painting lacked this feature when the poet saw it.[6] The torch is located on a strip of canvas 17¼ inches (44 cm) wide that runs along the entire left-hand side of the painting (fig. 27). Investigations of the ground layers and varnishes indicate that this strip was added after the rest of the paint had dried. The materials and methods utilized in creating the addition are entirely consistent with Rubens's approach to painting, and with the other portions of the Philadelphia picture. Peter Sutton, formerly the curator of northern European paintings at the Philadelphia Museum of Art, connects the addition to Rubens's comment in his letter to the English ambassador to the Dutch Republic, Sir Dudley Carleton, dated May 20, 1618: "I have entirely finished the *Prometheus* [and four other works]. . . . It is true, they are not yet dry, and still need to remain on the stretchers for some days before they can be rolled up without risk."[7] Sutton thus concludes that Rubens expanded his composition in 1618, just before sending it to Carleton as part of an exchange for the Englishman's collection of antiquities.

2 *Altitonans postquam certos secreuit in orbes*
Omnia, limitibus compescens Nerea certis,
Aura capit volucres, pisces versantur in undis,
Datq́ homini e celo flammas, animatq́ Prometheus.

IG. excud.

Plate 17

Artist unknown,
after **HENDRICK GOLTZIUS**
*Prometheus Making Man and
Animating Him with Fire from
Heaven*
1589
Engraving
Sheet: 8⅜ × 10⁷⁄₁₆ inches
(21.3 × 26.5 cm)
Philadelphia Museum of Art.
The Muriel and Philip Berman
Gift, acquired from the John S.
Phillips bequest of 1876 to the
Pennsylvania Academy of the
Fine Arts, 1985-52-1533

As Sutton also notes, expanding the painting to include the torch clarified the identity of its subject.[8] A muscled nude being devoured by a large bird could be confused for Tityus because both figures endured a similar punishment. The inclusion of the flame distinguishes Prometheus from the irredeemable Tityus, whose story does not include a torch or flame. At the same time, the fire alludes directly to Prometheus's role as creator. In the process, Rubens presents a scene that does not actually occur in the narrative, for by the time he was punished Prometheus had already given his gift to humanity. The expansion of the picture to include the torch brings all these elements to mind for the informed viewer.

Aneta Georgievska-Shine has explored how Prometheus symbolizes creative succession—the passing of knowledge from one person or generation to another.[9] He stole the fire and used it himself, but he also handed the flames over to humanity. His gift not only enabled humanity to develop all manner of technologies that are only possible with controlled heat and energy, it also metaphorically transferred the spark of creativity. Thus Prometheus was the conduit for the transfer of knowledge and the ability to create from the celestial to the terrestrial realm. Georgievska-Shine connects these ideas to Francis Bacon's 1609 poem "Prometheus, or the State of Man," which emphasizes the passing of the torch as a metaphor for progress by succession.[10] She rightly questions whether Rubens would have known of Bacon's text, but also suggests that Rubens's inclusion of the torch in the torture scene allows us to interpret the picture in the same manner.

AMBITION

The myth of Prometheus tells us that creativity and creative succession are ambitious and perilous undertakings. Prometheus did not simply bestow creativity on humanity—he had to steal it, and take the considerable risks associated with theft from the gods. As his punishment demonstrates, creation had its price. Its spark was considered strictly the domain of the Olympian gods. Even a Titan like Prometheus did not possess it, for he had to climb Mount Olympus to light his torch. Zeus and his fellow deities did not think that humanity should have access to this power. Yet, Prometheus risked punishment, stole the fire, passed it on, and paid the price for his transgressions.

The Dangers of Human Ambition (fig. 28), a 1549 etching by Dirck Volckertsz. Coornhert after Maarten van Heemskerck, explicitly addresses a central theme of the Prometheus myth. Here, dozens of figures attempt to climb a nearly sheer vertical cliff and cross a yawning chasm on a thin wooden plank. Heemskerck depicts the figures in various states of peril—stumbling on the plank, falling headfirst from the height, and sprawling on the ground, broken from the drop. In contrast, the merry group at left enjoys wine, dance, and music, free from danger. Lest one has trouble deciphering the visuals, the inscription makes the lesson clear:

> All who strive for lofty things tumble down head over heels in a
> Mighty whirl. As the highest of the high fall so it is with everything.
> Happy is he who has met with a modest lot, for he rejoices
> In a smooth road through life.[11]

Here ambition, fraught with peril, is vigorously advocated against. Like Icarus and Phaeton, those who extend beyond their means literally fall from grace. This correlates with Prometheus's appearance in several sixteenth-century emblem books—frequently with the admonition "curiositas fugienda" (curiosity should be shunned)—as the negative personification of inquisitiveness (fig. 29). Curiosity and ambition are linked concepts: In both, the individual seeks more and strives to attain it, regardless of cost or consequence.

Heemskerck's visual language in *The Dangers of Human Ambition* is closely aligned with Rubens's *Prometheus Bound*. Heemskerck illustrates the dangers of ambition with figures that fall in all manner

of contorted poses, while others lie on the ground in a tangled mass of limbs. Several bodies are upside down. Legs splay apart. Torsos bend and twist. None of these varied poses correlates directly with that of Prometheus, but the artist's experimentation with how to communicate movement through the male nude, particularly in an unsettling scene that explores the theme of ambition, ties this print to Rubens's painting.

As Miguel Falomir has recently noted, many artists in the late sixteenth and early seventeenth centuries took up the challenge of depicting falling, contorted bodies.[12] This trend is perhaps best exemplified by Goltzius's engravings of the *Four Disgracers* after Cornelis van Haarlem (see plates 9–12). Each print focuses on a single, contorted figure toppling through the pictorial space. The printed inscriptions identify them as Tantalus, Ixion, Phaeton, and Icarus, but each appears as a comparable male nude drawn from a different angle, showcasing the artist's ability to conceive of ever more imaginative poses as the figures perform complex dances based on the freedom of movement facilitated by their fall.[13] The various poses also presented a technical challenge, especially in the foreshortening they required. Goltzius creates the illusion of the recession into space of arms, legs, and torsos seen from top and bottom, front and back. Foreshortening of this kind required knowledge of perspective and physiognomy to make the illusion convincing. While most artists limited foreshortening to restricted passages, Goltzius's entire compositions rely on this skill, pushing the boundaries of what was artistically possible. The *Four Disgracers* visualizes the advice his friend and fellow Haarlem resident Karel van Mander issued in his 1604 treatise on painting. In a chapter on composition, Van Mander praised well-crafted figural variety, singling out

Fig. 28. Dirck Volckertsz. Coornhert (Dutch, 1522–1590) after Maarten van Heemskerck (Dutch, 1498–1574). *The Dangers of Human Ambition*, 1549. Etching, 17⁷⁄₁₆ × 19¹⁵⁄₁₆ inches (43.3 × 50.7 cm). Museum Boijmans Van Beuningen, Rotterdam. Acquired with the assistance of Stichting Lucas van Leyden

CVRIOSITAS FVGIENDA.

Fig. 29. Attributed to Bernard Salomon (French, c. 1508/10– c. 1561) or Pierre Eskrich (French, c. 1520–after 1590). *Curiositas fugienda*, 1552 (enlarged). From Barthélemy Aneau, *Picta poesis* (Lyon, 1552), p. 90. Woodcut, image: 1⁷⁄₁₆ × 2 inches (3.6 × 5.1 cm). National Gallery of Art Library, Washington, DC

Michelangelo's *Last Judgment* for "so many different appearances of the positions of the nudes."[14] Van Mander even advocated that "sometimes one should be posed as if falling, when it is appropriate."[15] Rubens must have been familiar with these theories, as he owned and annotated a copy of Van Mander's book.[16]

Goltzius's engravings derive directly from Heemskerck's print on *Ambition*, as has long been noted. But they also engage a lengthier tradition stimulated by sixteenth-century artists in Antwerp, including those who inspired Rubens—Bernard van Orley, Michiel Coxcie, and Frans Floris (see plates 5, 6; figs. 7, 9, 10). Like Goltzius, these artists grappled with the conceptual and technical challenges of rendering falling, foreshortened bodies, which became ambitious vehicles for demonstrating the full range of their artistic abilities. In this way, even as worldly ambition was being denigrated in Heemskerck's print and the Prometheus emblems of the sixteenth century, artistic ambition, especially in composition and figural pose, was worthy of praise.

Prometheus Bound is a tour de force of painting. Like Goltzius's *Disgracers*, especially *Phaeton*, Rubens designed his figure so that he had to fore-

shorten the torso and both legs. Also like Goltzius, he did not conceal the body with drapery, so that the artist's abilities are on full view. This daring composition, combined with his synthesis of the most esteemed masters of the ancient and recent past, begins to illuminate Rubens's ambitions.

Adding the torch to the scene not only clarified the subject and highlighted the theme of creativity in the narrative, but it also constituted another pictorial achievement (fig. 30). Painting fire was a particular challenge for the premodern artist. At the most basic level, flames created difficult lighting scenarios and challenged painters with their elusive ephemerality. Writers from Pliny the Elder and Philostratus to Erasmus and Baldassare Castiglione had praised painters who convincingly depicted flames.[17] Collectors such as Federigo Gonzaga, the Duke of Mantua, who owned twenty paintings with fire in them, seem to have been particularly drawn to the audaciousness of those who could paint flames.[18] Though Rubens's torch does not cast dramatic shadows because the painting is a daytime scene, it is nonetheless highly successful. The end of the stalk pulsates with heat in tones that range from light yellow to robust orange. Each note of slightly modulated color has been applied with deft touches of the brush to create irregular, occasionally overlapping shapes. As a result, the flames appear to dance and flicker. The whirling tendrils of gray smoke that waft toward the sky appear thickest near the flame, dissipating as the smoke meets the air. In these ways, Rubens captures in the static medium of paint the sense of movement and spontaneity that are at the heart of visual experiences of flame.

The scale at which Rubens painted *Prometheus Bound* also indicates the ambitiousness of the undertaking. Measuring nearly eight feet by seven feet, this is a large painting. It is not extreme by Baroque standards—and others by Rubens are larger—but its size magnified the challenges that the artist set for himself. The figure of Prometheus is more than life-size when foreshortening is taken into account. The foreshortened limbs, the eagle's piercing talons, Prometheus's lacerated liver, even the flickering flames

and billowing smoke stand out more because they are large. Rubens once said, "My talent is such that no undertaking, however vast in size . . . has ever surpassed my courage." Indeed, when taken as a whole, *Prometheus Bound* exemplifies Rubens's own artistic ambitions as well as any of his pictures.

COLLABORATION AND SHARED AMBITION

As ambitious as Rubens was in undertaking *Prometheus Bound*, he was not alone in the endeavor. In his letter to Carleton, shortly before sending the ambassador the painting, the artist noted that the canvas was an "original, by my hand, and the eagle done by Snyders."[19]

Frans Snyders specialized in painting animals and still lifes. After training with Pieter Brueghel the Younger, and possibly with Hendrik van Balen, Snyders registered as a master in the painter's guild in Antwerp in 1602. By at least the spring of 1608 Snyders was in Italy, first in Rome and then Milan. Just over a year later, by July 1609, Snyders was back in Antwerp. His return coincided with that of Rubens, and Susan Koslow has suggested that the two artists may have met in Rome.[20] Born but two years apart, Rubens and Snyders were closely connected in many ways. Between 1611 and 1620 they lived a scant two blocks from each other, and they worked together dozens of times over the course of their careers.[21] In 1636, Rubens helped Snyders earn a commission from King Philip IV of Spain for sixty animal scenes to decorate his hunting lodge, the Torre de la Parada. Upon Rubens's death in 1640, Snyders served as one of the assessors of his colleague's collections of art.

By the time of their collaboration on *Prometheus Bound*, between 1612 and 1618, Snyders was an accomplished artist with an international reputation of his own (fig. 31). A 1613 letter from Brueghel, dictated to Rubens, describes Snyders as a unique talent whose work is in high demand and garners ever-increasing prices.[22] By 1616, Snyders had taken on two pupils to help him manage the workload.[23] In 1619 he was elected to the Brotherhood of Roman-

ists in Antwerp, an exclusive club of twenty-five men (mostly city officials and elite merchants) who had been to Rome.[24] In 1620 the artist purchased a large house with a courtyard on the Keizerstraat, one of Antwerp's wealthiest and most fashionable addresses.[25] Anthony van Dyck's portrait of Snyders from around 1620 (fig. 32), commissioned to decorate his elegant new home, shows just how successful the artist had become. Clad in tasteful but opulent silk and delicate lace, with a cloak slung across one shoulder, Snyders poses nonchalantly behind a leather-backed chair. A rich purple swag of drapery obstructs the landscape vista that opens behind him. Nowhere is there a brush or other reference to his profession. Rather, Snyders appears like the gentlemen in whose social circles he moved. The wealth needed to place Snyders in this company came from his burgeoning studio. Indeed, by 1621 he could count Archduke Albert and Archduchess Isabella of Brussels, the Austrian Habsburgs, the English ambassador Carleton, and George Villiers, Duke of

Fig. 30. Detail of *Prometheus Bound* (see plate 1) showing the torch in the lower left-hand corner

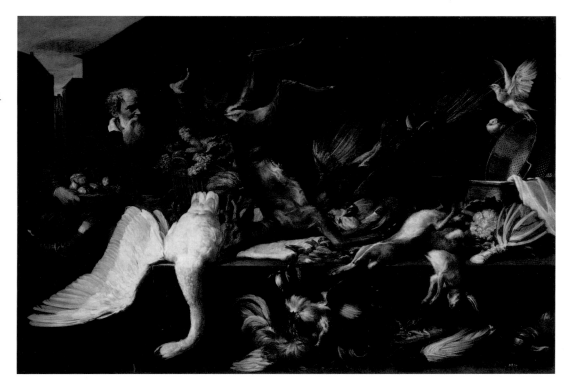

Fig. 31. Frans Snyders. *Still Life with Dead Game, Fruits, and Vegetables in a Market*, 1614. Oil on canvas, 7 feet × 10 feet 1 inch (2.1 × 3.1 m). The Art Institute of Chicago. Charles H. and Mary F. S. Worcester Collection, 1981.182

Fig. 32. Anthony van Dyck (Flemish, 1599–1641). *Frans Snyders*, c. 1620. Oil on canvas, 56⅛ × 41½ inches (142.6 × 105.4 cm). Frick Collection, New York

Buckingham, among his international clientele. Thus Snyders's involvement in *Prometheus Bound* cannot be understood as the participation of an assistant or low-ranking specialist. Rather, Rubens and Snyders formed a partnership between two master painters of international prominence.

Collaboration between two such masters was common practice in early seventeenth-century Antwerp.[26] Elizabeth Honig has gone so far as to argue that it was "a defining mode of artistic activity."[27] She estimates, for example, that one-quarter of Snyders's artistic endeavors were collaborative.[28] This type of calculation is more challenging for Rubens, since divining the artist's hand from those of his assistants is difficult, but numerous examples exist of his collaborations with fellow painters in Antwerp. Rubens worked frequently with Jan Brueghel the Elder in the 1610s, and, in addition to *Prometheus Bound*, he collaborated with Snyders on three other prominent paintings: *The Recognition of Philopoemen* from about 1609 (fig. 33), *Diana Returning from the Hunt* from around 1616 (Gemäldegalerie Alte Meister, Dres-

Fig. 33. Peter Paul Rubens and Frans Snyders. *The Recognition of Philopoemen*, c. 1609. Oil on canvas, 6 feet 7 inches × 10 feet 3 inches (2 × 3.1 m). Museo Nacional del Prado, Madrid

Fig. 34. Peter Paul Rubens. *Sketch for "The Recognition of Philopoemen,"* c. 1609. Oil on panel, 19¹¹⁄₁₆ × 26 inches (50 × 66 cm). Musée du Louvre, Paris

den), and *Head of Medusa* from 1617–18 (Gemäldegalerie, Kunsthistorisches Museum, Vienna).

A painted sketch for *The Recognition of Philopoemen* (fig. 34) now in the Louvre suggests how Rubens and Snyders worked together. Executed entirely by Rubens, the sketch shows the full composition, even though on the finished painting he executed only the human figures at left, which take up less than a third of the canvas. Rubens allotted space for the still-life elements that dominate the scene and placed several specific motifs. Snyders deviated from Rubens's design in a few passages: he enlarged the peacock at left, replaced the hare that dangled over the table with a deer, and amplified the exotic fowl clustered at bottom right, among other changes. Thus, Snyders possessed significant creative input, but he still worked within a scheme created by Rubens. Correspondence to Rubens regarding the Torre de la Parada commissions confirms this division of labor, stipulating: "Everything by your hand and by Snyders, from the former the figures and landscapes and from the other the animals."[29] In both instances,

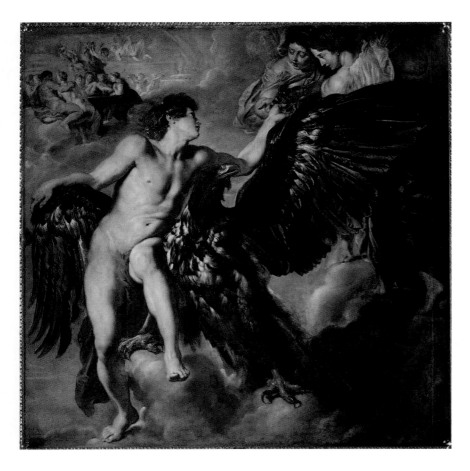

Fig. 35. Peter Paul Rubens. *Zeus and Ganymede*, 1611–12. Oil on canvas, 79⅞ × 79⅞ (203 × 203 cm). Schwarzenberg Palace, Vienna

Like a duet, a collaborative painting enables an audience to enjoy the achievement of two artists simultaneously. In this instance, viewers can revel in a picture that was produced by the premier figure painter and the leading painter of animals of the day. Furthermore, the eagle and the human figure are of equal importance to the narrative as Rubens conceived it: a moment of conflict between two characters—a protagonist and an antagonist. Positioned on a parallel diagonal axis with the title character, the eagle mirrors its victim. Its impressive wings span a distance greater than that occupied by the giant Titan. As the attacker, the eagle activates the scene, propelling the narrative forward.

While no sketch for the composition survives, Snyders's drawn study of the eagle (plate 18) is extant. From the beginning, he designed a ferocious beast. With its talons exposed and extended, the eagle leers menacingly at the prone figure. The feathers at its neck splay outward to create a mane of unkempt energy. Its beak is sharp and open. The lightest of lines indicate where the eagle grasps the shorn liver in its beak. Snyders altered the painting only slightly from his sketch. As Koslow notes, the space between head and left talon has been extended to give more prominence to each part, and the shape of the left wing has been changed.[30] In the painting, the feathers at the tip have been sharpened, and the wing has been attached higher on the torso to more accurately convey how it would have arched upward. These are minor changes that heighten the dynamism of an already vigorous image.

Snyders's eagle is more naturalistic and dynamic than the one Rubens painted in *Ganymede*. Though Rubens's eagle bears Ganymede heavenward, the image is a static one: Feathers are locked in place; wings extend but do not flap. Koslow also points out that Rubens devoted so much attention to the individual feathers, distinguishing those that are gray and white from those that are brown, that the surface appears too plotted. Snyders's eagle, with its softer feathers, is less sculptural and more vital. The mottled white feathers lie more convincingly within an overall color scheme. Snyders's eagle appears

Rubens was responsible for the greater part of the picture and the entirety of the design, while Snyders provided a valued but secondary contribution based on his particular skills.

Returning to *Prometheus Bound*, Rubens was fully capable of designing and executing a large-scale eagle that dominates a narrative scene, as his *Zeus and Ganymede* (fig. 35) from 1611–12 demonstrates. By at least 1613 Rubens owned a copy of Ulisse Aldrovandi's *Ornithologia* (1603). This seminal illustrated volume on birds, by one of the founders of modern zoology, coupled with his access to the extensive aviary of his patrons Albert and Isabella in Brussels, would have provided all the material necessary for an artist of Rubens's caliber to craft a naturalistic looking bird of prey. Instead, Rubens enlisted his colleague Snyders to contribute the eagle.

Collaborating with Snyders empowered Rubens to create an even more dynamic visual experience.

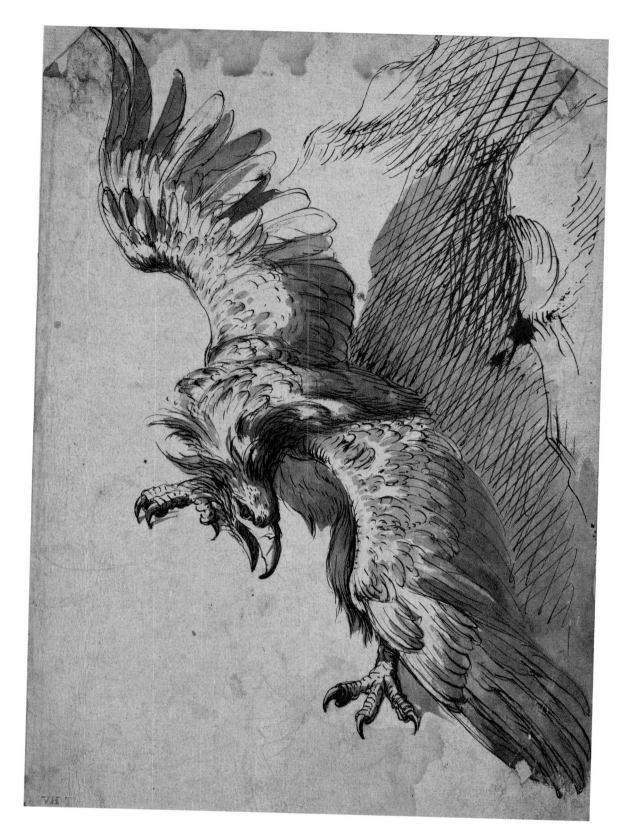

Plate 18
FRANS SNYDERS
Study for Prometheus
1612
Pen, brown ink, and brown
wash on paper
11¹⁄₁₆ × 7¹⁵⁄₁₆ inches (28 × 20.2 cm)
The British Museum, London

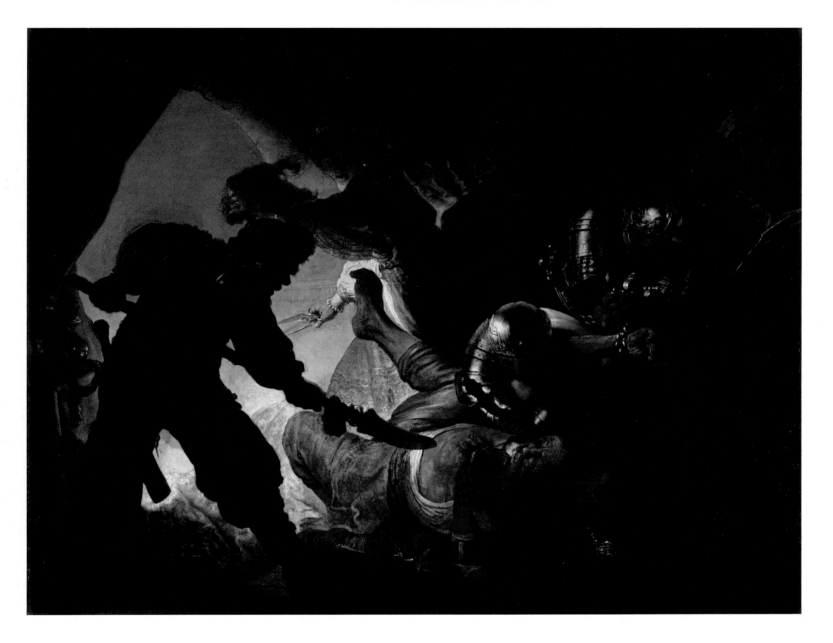

Fig. 40. Rembrandt Harmensz. van Rijn (Dutch, 1606–1669). *The Blinding of Samson*, 1636. Oil on canvas, 6 feet 9 inches × 9 feet 2 inches (2 × 2.8 m). Städel Museum, Frankfurt

Bernard Mandeville wrote in 1728, the value of works of art was partially defined by "the Quality of the Persons in whose Possession they are."[34]

Beginning in 1611, Rubens had also sought to circulate his works more widely through reproductive prints.[35] Among the earliest of these is the undated *Judith Beheading Holofernes* (plate 19), engraved by Cornelis Galle I after a painting that is now lost. Rubens pictured the Jewish heroine in the act of severing Holofernes's head to save the people of Bethulia from Assyrian oppression. The scene is a gruesome one, with Judith's sword lodged halfway through Holofernes's neck as blood gushes out in multiple streams. Holofernes struggles with tense, contracted muscles and veins popping in his forearms and calf. His eyes roll back as Judith calmly forces his head down to give her a clearer view of her target. The violence, classically proportioned nude body, and precariously prone posture align with those Rubens utilized in *Prometheus Bound*.

Less expensive than paintings and existing in multiple copies, prints such as *Judith Beheading Holofernes* reached a relatively broad audience. Indeed, in 1619 Rubens received privileges (an

Cedite Romani ductores, cedite Graii: Veſtra fuit magna victoria parta virum vi, Barbarus vnius dextra cadit Induperator,
Obſtruxit veſtris femina luminibus. Et ceſſit laudis pars bona militibus; Defendit patriæ perniciem vna manus.

Clariſſ. et amiciſſimo viro D. IOANNI WOVERIO paginam hanc auſpicalem primamque ſuorum operum
typis. tenet. expreſſam PETRVS PAVLLVS RVBENIVS promiſſi iam olim Veronæ a ſe facti memor DAT DICAT.

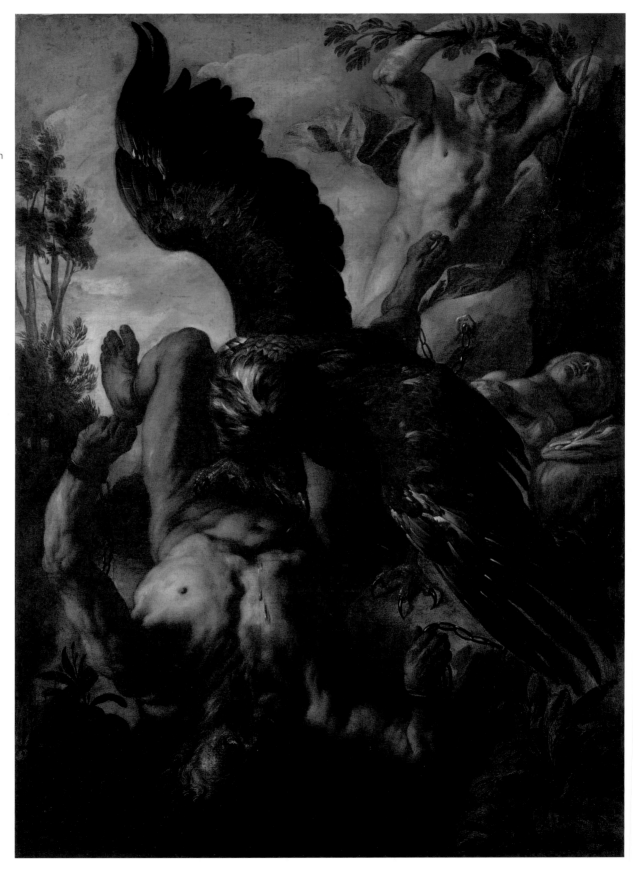

early form of copyright) from the Spanish Netherlands, France, and the Dutch Republic to protect his intellectual property manifested in his prints. These various privileges, which were printed below the images, indicate that Rubens's engravings circulated in at least these three regions, and that he was acutely aware of the need to protect his creations—and, by extension, his artistic and market identities—against infringement. In the case of the *Judith Beheading Holofernes*, the print associated Rubens with an image of intense violence.

There is no known print after *Prometheus Bound*. Perhaps this is because the exchange with Carleton concluded too quickly for Rubens to have a reproduction of the painting made before it left for The Hague and was not as accessible as pictures that found homes nearer to Antwerp.[36] As Eric Jan Sluijter has recently argued, however, the painting was famous nonetheless thanks to Baudius's ekphrastic poem.[37] Published in 1616, the poem described in detail the horrific nature of the image and the considerable impact it made on the viewer. Thus, like a reproductive print, it circulated an image—though one in words—of Rubens's achievement.

Sluijter also argued that the painting would have been well known in humanist circles in Holland. Marloes Hemmer has recently mapped the intricate interconnections between myriad intellectuals within the Dutch Republic and their counterparts in Rubens's Flemish milieu.[38] The very presence of *Prometheus Bound* in Carleton's collection in The Hague must have been noteworthy. As a large-scale painting by the revered Rubens of a gruesomely graphic scene, famously described by Baudius, that reiterated the aesthetic of *Judith Beheading Holofernes*, Rubens's canvas would have attracted the attention of artists and connoisseurs alike, furthering the Flemish master's fame. That important artists like Van Baburen and Rembrandt emulated this grand painting would have further cemented its esteem.

In 1625 Carleton left his post as English ambassador to the Dutch Republic and returned to London to become vice-chamberlain of the household

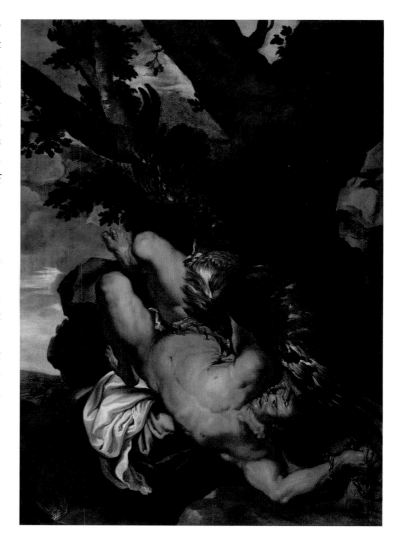

and privy councilor to Charles I. Presumably, Carleton took his art with him, but it is not known what happened to his collection when he died in 1632.[39] *Prometheus Bound* is next documented in 1687 in the inventory of Kimbolton Castle in Huntingdonshire, the residence of the earls and dukes of Manchester.[40] It is possible that the painting passed from Carleton to Edward Montagu, the second Earl of Manchester. Montagu accompanied Prince Charles to Spain in 1623 and served several terms in Parliament before becoming chancellor of Cambridge University. He was also later involved in the Restoration. In any of these capacities he could have acquired *Prometheus Bound* from Carleton or an intermediary. In any event, the painting likely remained in England from 1625 until it was sold at auction in 1949.

Fig. 41. Artist unknown, copy after Peter Paul Rubens. *Prometheus Bound*, probably late seventeenth or early eighteenth century. Oil on panel, 41¾ × 29¹³⁄₁₆ inches (106 × 75.7 cm). Palais des Beaux Arts de Lille, France

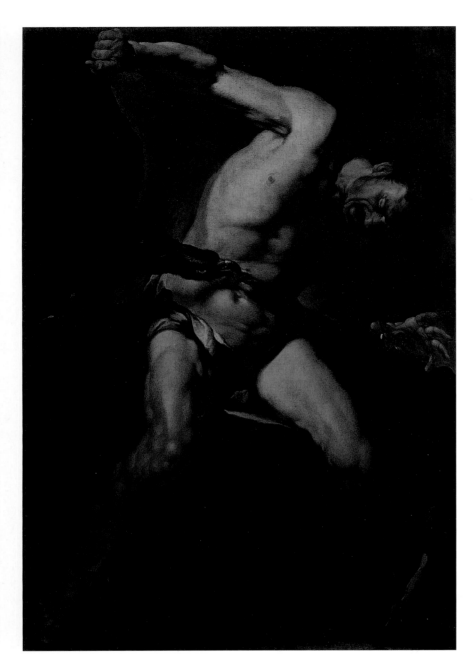

Fig. 42. Attributed to Luca Giordano (Italian, 1634–1705), or possibly Giovanni Battista Langetti (Italian, 1635–1676). *Prometheus*, c. 1655–60. Oil on canvas, 72¹³⁄₁₆ × 50 inches (185 × 127 cm). Perth Museum and Art Gallery, Perth and Kinross Council, Scotland

neck and shoulders. Indeed, the figure looks more like one by Rembrandt than one by Rubens. While following Rubens in placing a torch at lower left, Jordaens added Hermes, a sculpted bust, and a bundle of bones to the composition. As Jonathan Bikker has cogently argued, Jordaens's modifications can be traced to his decision to develop his painting from Lucian's satirical version of the myth, as Van Baburen had.[41] Red-faced, with boorish features and howling like an oaf, as one scholar described the figure, Jordaens's Prometheus does elicit a comic response.[42] Hermes's bemused smirk solidifies this lighthearted tone. The bones relate to the episode in which Prometheus tricks Zeus into accepting a bundle of bones wrapped in fat rather than lean, delectable meat as a sacrifice. The sculpture references the humanoid figure Prometheus crafted from clay, which he needed the Olympian fire to animate.[43] In Lucian's version of the myth, Hermes accuses Prometheus of three misdeeds: stealing fire, creating humanity, and deceiving Zeus. The humor comes from Prometheus's unsuccessful arguments to escape punishment—and his less-than-dignified response to that punishment when it eventually arrives. Jordaens distilled these various narrative elements into a single scene.

Like Rembrandt, Jordaens references Rubens's canvas as a means to pit himself against the master and create a pictorial argument for his artistic prowess.[44] Rubens's recent death in 1640 may have spurred Jordaens to contemplate and respond to the older painter's masterful exploration of creative struggle. Jordaens had collaborated with Rubens in 1637–38 on a commission for King Philip IV of Spain's hunting lodge, the Torre de la Parada. In 1641, Jordaens bought a new, luxurious residence in Antwerp.[45] Like Rubens before him, perhaps the younger artist needed large, ambitious paintings to decorate his new home. He may even have been inspired by seeing Rubens's *Prometheus Bound* installed in the Rubenshuis before 1618. With Rubens's passing and Anthony van Dyck's death in 1641, perhaps Jordaens also sought to establish himself as the preeminent living Flemish

In about 1640 Jacques Jordaens executed one of the greatest responses to Rubens's *Prometheus Bound*. In a painting of almost the exact same size (plate 20), Jordaens crafted a monumental image of an upturned Prometheus having his liver devoured by an eagle that is nearly identical to the one painted by Frans Snyders. The palette is similar to Rubens's, but Jordaens's vision of Prometheus differs considerably. Here the Titan is older, sporting gray hair and a beard, and has a softer body, with fleshy folds at the

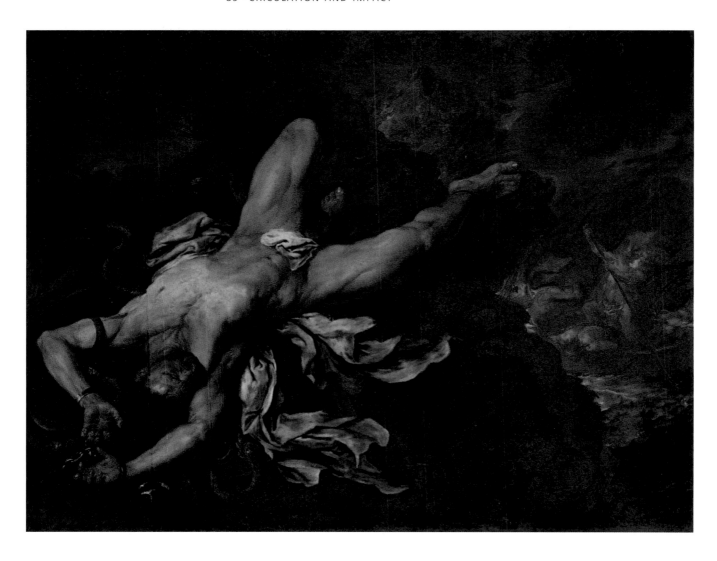

painter. In any event, Jordaens did ascend to the perch of the leading history painter in the southern Netherlands until his own death in 1678.

Whatever his motivations, it is unclear how Jordaens came to know Rubens's painting well enough to reproduce the eagle so accurately in the early 1640s, more than twenty years after the picture left Antwerp. The artist ventured north to the Dutch Republic in 1632, but *Prometheus Bound* had likely already departed for England. In 1639, Jordaens received a commission for a series of twenty-two paintings of the story of Cupid and Psyche for the queen of England's chambers in Greenwich, but he does not seem to have traveled across the Channel for this project. This commission was transacted through Baltasar

Gerbier, Charles I's agent in Brussels, and Alessandro Scaglia, the Savoy diplomat in Brussels who had previously been in London. Perhaps Gerbier or Scaglia fueled Jordaens's interest in Prometheus, reminding him of Rubens's highly successful version, which either might have spied recently in England. Another possibility that has never been examined thoroughly is that Jordaens collaborated with Snyders on his own *Prometheus*.[46] This would explain the almost exact replication of the eagle, especially as Jordaens so rarely painted birds of this type and scale successfully.

Painted copies of Rubens's *Prometheus Bound* may have spread knowledge of the painting further afield. Peter Sutton identified an early copy pur-

Fig. 43. Giovanni Battista Langetti. *The Torture of Ixion*, c. 1663. 6 feet 4 inches × 9 feet 8 inches (1.9 × 2.6 m). Museo de Arte de Ponce, Puerto Rico, The Luis A. Ferré Foundation, Inc.

chased by the Duke of Oldenburg in 1809.[47] Another copy (fig. 41), probably from the late seventeenth or early eighteenth century, is less than half the size of Rubens's canvas. Even though its execution pales in comparison to Rubens's original, a painting such as this would have circulated the composition and coloring. A painted copy of *Prometheus Bound* may also have reached the Italian peninsula by the second half of the seventeenth century. As Falomir has explored recently, Italy in the 1640s to 1660s saw a near mania for monumentally scaled images of tortured souls, including Tityus, Marsyas, Ixion, and Prometheus.[48] Innumerable artists such as Jusepe de Ribera, Salvator Rosa, Luca Giordano, and Giovanni Battista Langetti painted images of this type. These artists would have had access to some of the same pictorial sources as Rubens—from the Laocoön to Michelangelo's intense figures to Caravaggio's gruesome scenes—but some of their pictures bear more than a passing resemblance to *Prometheus Bound*, suggesting that they may have been familiar with Rubens's composition.

A large-scale *Prometheus* in the Perth Museum and Art Gallery in Scotland (fig. 42), attributed variously to Giordano or Langetti, recalls the Philadelphia picture more than others.[49] Prometheus is presented upright, but a number of the painting's features—the three-quarter-view of the face with its shadow of scruffy beard, the tousled hair, the upraised arm, the exposed and torqued torso, and the one extended and one bent leg—relate to Rubens's vision. Langetti's *Torture of Ixion* of 1663 (fig. 43) is even closer in pose to *Prometheus Bound*. Ixion's body is leaner, but the position of the left arm, the bent left leg foreshortened to expose a bit of the foot, the extended right leg, and the face turned to the right all relate directly to Rubens's canvas. Falomir has also linked *Ixion* to Rubens's *Juno and Argus* (see fig. 18), which was with the Balbi family in Genoa from 1618 through the end of the eighteenth century.[50] A Genoan

who trained as a painter in his native city before embarking on a career in Rome and Venice, Langetti would have had ample opportunity to study *Juno and Argus*. That said, the placement of Ixion's left arm is the same as that of Prometheus, but not that of Argus. More so, Argus has been beheaded, whereas the twist of Ixion's neck that presents the face in three-quarter view, the open mouth, and the hint of facial hair recall Rubens's treatment in the Philadelphia painting.

As none of these Italian artists is known to have traveled north of the Alps to any of the locations where *Prometheus Bound* may have hung after 1625, they could only have known Rubens's picture through a painted copy. More importantly, these Italian pictures begin to suggest the impact that Rubens made on artists there nearly half a century after the Flemish master had absorbed the styles and forms of Titian, Michelangelo, and others.

Rubens's impact on succeeding generations of artists is a well-traversed subject. His contributions to French art of the eighteenth and nineteenth centuries in particular have been studied extensively.[51] Likewise, his impact on fellow painters in Antwerp and environs in the seventeenth century is well known. In both places, Rubens's aesthetics as a whole were absorbed and digested. What I have attempted to suggest here is that *Prometheus Bound* produced a singular and emphatic effect on artists. We can trace how Dutch, Flemish, and perhaps even Italian artists engaged with this painting, even if it was through intermediary reproductions. That *Prometheus Bound* may have originated as a private picture for Rubens's residence makes such wide diffusion all the more remarkable. Perhaps because the picture was tied in so many ways to Rubens's personal taste—philosophical as well as aesthetic—*Prometheus Bound* appealed to other artists as an ideal vehicle through which to engage the man and his art.

CODA: AN ENDURING MYTH

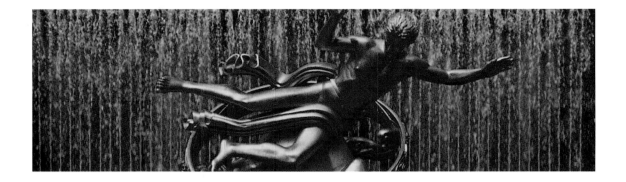

I N THE CENTURIES SINCE Rubens painted *Prometheus Bound*, visual and literary artists have continued to explore themes of struggle, creation, and progress using the tortured Titan as their subject. A brief survey of some of these works suggests how this myth has captured artistic and popular imaginations alike. Taken together, these examples argue for the contemporary relevance of the works of art in the present exhibition and the stories that inspired them.

ROMANTIC REVIVAL

Though Prometheus was a common subject for art in the seventeenth century, he appeared infrequently for much of the eighteenth century.[1] It was not until the 1780s, with the rise of Romanticism, that Promethean imagery enjoyed a resurgence, especially in literature. Harriet Hustis has called Prometheus the paradigmatic myth of the Romantic movement.[2] Johann Wolfgang von Goethe, Lord Byron, and Percy Shelley all dedicated works to the Titan.[3]

In 1789, Goethe celebrated Prometheus as a rebel and suffering artist.[4] In an 1816 poem, Byron also perceived Prometheus's suffering as emblematic of the human condition:

[Prometheus] thou art a symbol and a sign
To Mortals of their fate and force;

Like thee, Man is in part divine,
A troubled stream from a pure source.[5]

Rather than a poem, Shelley penned the lyrical play *Prometheus Unbound*, published in 1820. In the preface, he compares Prometheus to the character of Satan in Milton's *Paradise Lost*:

The only imaginary being, resembling in any degree Prometheus, is Satan; and Prometheus is, in my judgment, a more poetical character than Satan, because, in addition to courage, and majesty, and firm and patient opposition to omnipotent force, he is susceptible of being described as exempt from the taints of ambition, envy, revenge, and a desire for personal aggrandizement, which, in the hero of *Paradise Lost*, interfere with the interest. The character of Satan engenders in the mind a pernicious casuistry which leads us to weigh his faults with his wrongs, and to excuse the former because the latter exceed all measure. In the minds of those who consider that magnificent fiction with a religious feeling it engenders something worse. But Prometheus is, as it were, the type of the highest perfection of moral and intellectual nature impelled by the purest and the truest motives to the best and noblest ends.[6]

Though virtuous, Shelley's Prometheus rebels against authority and is deemed a heroic figure for his transgressions. Indeed, this aspect of the myth resonated with artists and writers who themselves

Fig. 44. Title page from Mary Wollstonecraft Shelley, *Frankenstein; or, The Modern Prometheus*. London: Lackington, Hughes, Harding, Mavor and Jones, 1818. University of Pennsylvania Libraries, Rare Book and Manuscript Library. Singer-Mendenhall Collection

Fig. 45. Engraved by Abraham Raimbach (English, 1776–1843) after Robert Smirke (English, 1752–1845). Frontispiece from *Poems on the Abolition of the Slave Trade*. London: R. Bowyer, 1809. The British Library, London

responsibilities that accompany creation, whether biological or artistic. For Shelley, as for Goethe and Byron, Prometheus served as the ideal vehicle through which to explore the core concepts associated with Romanticism.

ENSLAVEMENT

In the early nineteenth century, Prometheus also became the embodiment of enslavement. This point is made clear in *Poems on the Abolition of the Slave Trade*, a volume celebrating the passage of the Slave Trade Act of 1807, which outlawed the practice in all parts of the British Empire. An engraving of Prometheus freed from Mount Caucasus by Hercules served as frontispiece (fig. 45), and James Grahame contributed the poem "Prometheus Delivered" to the volume. Grahame compares the plight of enslaved Africans with that of the mythic Titan—calling Prometheus "outcast, captive, victim, slave"— and positions Britain as Hercules, who "smites the rock and rends the chain" so that "Prometheus rises man again!"

Edith Hill has traced the link between Prometheus and abolitionism to Aeschylus's version of

defied tradition. Prometheus epitomized the Romantic idea that growth and creativity were only possible through rebellion.

Two years earlier, Mary Shelley had constructed her own Promethean character in *Frankenstein* (fig. 44). Indeed, the subtitle of her novella is "The Modern Prometheus."[7] While later adaptations of Shelley's creation, especially cinematic ones, have labeled the created being Frankenstein, it is in fact the doctor, Viktor Frankenstein, who is the true subject of her story. Like Prometheus, Dr. Frankenstein creates a humanoid figure and animates it with lightning, an analogue to Olympian fire. As things go awry for Frankenstein and his monster, Shelley's text looks at the dark side of Romantic genius, the struggles of creation, and the consequences of rebelling against the natural order.[8] Shelley modernized the Promethean myth, crafting her own exploration of the perils and

Fig. 46. "Marx as Prometheus in Chains," 1843. Editorial cartoon from *Rheinische Zeitung*, Cologne. Courtesy akg-images

the myth.[9] Hill notes that the first English and French translations of the Greek tragedian's *Prometheus Bound* appeared in the 1770s, concurrent with the nascent abolitionist movement in Europe.[10] She argues that Prometheus operated as the archetypal myth for abolitionists, validating their efforts through the classical precedent of an enslaved figure who was freed through intervention.

Hill also suggests that, through the work of abolitionists like Grahame, Prometheus became a general symbol for the oppressed. To take but one example, Karl Marx is pictured as Prometheus in a political cartoon from the Cologne newspaper *Rheinische Zeitung* (fig. 46), published following the 1843 suppression of his writings. Marx is shown chained to a printing press while an eagle wearing the Prussian crown begins to lacerate his abdomen. In 1998, the British poet-turned-direc-

tor Tony Harrison invoked the Titan in his film *Prometheus*, about humanity's uses and abuses of fire. Traversing the postindustrial landscape of closed mines and carbon factories, Harrison crafts an eloquent and sympathetic look at the plight of the workers and communities whose livelihood depended upon these sites.[11] From Grahame to Marx to Harrison, Prometheus functioned as a sympathetic emblem of the oppressed throughout the nineteenth and twentieth centuries.

Gustave Moreau's 1868 painting *Prometheus* (fig. 47) illuminates how even while chained the Titan could still be presented as a heroic figure. Unlike nearly all previous artists, Moreau presented Prometheus upright. Though chained to the crags, Moreau's figure sits nobly and stares intently across the space. The vulture sitting beside him drips blood from its beak, but Prometheus is

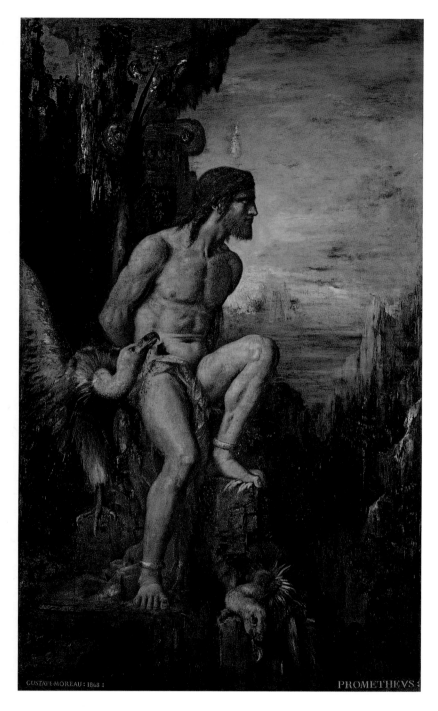

unfazed by the attack and the gaping wound to his abdomen. Moreau further ennobles Prometheus by bestowing him with long golden locks and a full blond beard, so that he appears decidedly Christ-like—a resemblance that was not lost on those who saw the painting in the 1869 Salon in Paris. As Théophile Gautier wrote in the May 15, 1869, edition of *L'Illustration*:

[Prometheus] is a man who it seems to us the artist meant, to a degree, to make resemble Christ, of whom, according to some fathers of the Church, he is a figure and a pagan prediction. For he, too, wanted to redeem man and suffered for them. He, too, was nailed to a cross of rock and had a perpetually bleeding wound to his chest.[12]

As Gautier's commentary suggests, audiences were already prepared to draw the comparison to Christ, and, by extension, issue positive assessments of Prometheus's actions and character. Indeed, the story of Prometheus was widely available in the nineteenth century. For example, at least twelve English translations of Aeschylus's *Prometheus Bound* were published between 1822 and 1853, including Henry David Thoreau's version of 1843.

ICON OF PROGRESS

In the twentieth century, Prometheus continued to capture the imaginations of artists, but they tended to focus on his gift to humanity, rather than his enslavement. In 1930, José Clemente Orozco decorated the dining hall at Pomona College in California with a mural dedicated to Prometheus (fig. 48), crafted as a monumental figure reaching skyward for the fire he will give to the writhing mass of humanity that encircles him. The implication is that this fire will guide them to all manner of achievements in technology and the arts. This was the artist's first major commission in the United States, and Orozco may have identified with his subject, seeing himself as a hero who enlightened others.

The most iconic image of Prometheus in the United States is Paul Manship's 1934 sculpture at

Fig. 47. Gustave Moreau (French, 1826–1898). *Prometheus*, 1868. Oil on canvas, 80¾ × 48⁄₁₆ inches (205 × 122 cm). Musée National Gustave Moreau, Paris

Rockefeller Center in New York (fig. 49). Manship presents—in gilt bronze—Prometheus descending Mount Olympus with the flames in his right hand. Nothing in the work communicates struggle, transgression, or anything other than the Titan's gift to humanity. A quote from Aeschylus inscribed on the red granite wall behind the sculpture echoes the heroic tenor of Manship's creation: "Prometheus, Teacher in Every Art, Brought the Fire That Hath Proved to Mortals a Means to Mighty Ends."

Manship may have been inspired by the reintroduction of the flame and torch into the Olympics, beginning with the 1928 summer games in Amsterdam. As in ancient torch races, the Olympic flame is now lit by the sun via a parabolic mirror before it is carried by relay from Olympia, Greece, to the host city. The International Olympic Committee acknowledges the myth of Prometheus as the inspiration for the flame and the relay.[13] Likewise, the English phrase "passing the torch" derives directly from the myth, celebrating not the fire itself, but Prometheus's selfless act of bringing it to humanity.

BEGINNINGS

Prometheus has also been invoked to explore the origin of human civilization. Perhaps the most eloquent example is Constantin Brancusi's *Prometheus* of 1911 (fig. 50), a simple ovoid form whose only features are a barely discernable nose and ocular cavities. As a result, the sculpture resembles both a head and an egg, and the translucence of the marble amplifies these embryonic qualities.[14] In this way, Brancusi's sculpture evokes beginnings and formations that are both literal and metaphorical, its title connecting the marble to the generative passages in the myth.

More recently, Ridley Scott explored this theme in his 2012 film *Prometheus*. Early in the film, an alien arrives on an as-yet-unpopulated earth. Drinking a liquid that causes his body to disintegrate, the alien seeds the planet with the microscopic beginnings of life. Billions of years later, at the end of the twenty-first century, a group of astronauts sets out—in a spacecraft called *Prometheus*—to find these beings whose interventions are akin to the Titan's gift of the creative spark. The crew of the *Prometheus* has a second objective—to collect and harvest a recently discovered alien life form for experimentation and possible weaponization. These aliens turn out to be parasites that attack the crew and would threaten humanity if brought back to earth. This part of the film connects with the story of Pandora, who unleashed all manner of evils on humankind by opening the box from Zeus.

The spacecraft in Scott's film carries on a long tradition of naming vessels after the tortured Titan; a number of British and American ships have been christened the HMS and USS *Prometheus*, respectively.[15] In the realm of science fiction, the American television series *Stargate* (1997–2011) dubbed the first spacecraft that combined human and alien technology *Prometheus*. This followed *Star Trek: Voyager* (2005–11), which had earlier named a class of spaceship after the myth. The penchant for naming ships after the hero suggests how the myth has long been tied to notions of movement, transportation, and progress.

OPEN TO INTERPRETATION

As the examples above suggest, artists have long reimagined, if not outright reinvented, the Prometheus myth to serve different creative ends. To further illustrate the point, take Jacques Lipchitz's 1943 sculpture *Prometheus Strangling the Vulture* (fig. 51), now installed outside the Philadelphia Museum of Art. Writ large in bronze, Prometheus and the vulture are locked in combat. Reversing Rubens's composition, Lipchitz's Prometheus towers aggressively above the bird as, with flexed biceps and forearms, he grasps a talon in one hand and the bird's neck in the other. No chain impedes Prometheus—indeed, he appears completely unrestrained. Lipchitz upends the ancient myths

Fig. 48. José Clemente Orozco (Mexican, 1883–1949). *Prometheus*, 1930. Fresco mural, 20 feet × 28 feet 6 inches (6.1 × 8.7 m). Frary Dining Hall, Pomona College, Claremont, California

Fig. 49. Paul Manship (American, 1885–1966). *Prometheus*, 1934. Gilded cast bronze, height 18 feet (5.5 m). Rockefeller Center, Channel Gardens and Promenade, New York

and their modern translations, presenting us with a Prometheus who is fully in control of his fate.

Percy Shelley described a similar process of reworking classical myths in his preface to *Prometheus Unbound*:

The Greek tragic writers, in selecting as their subject any portion of their national history or mythology, employed in their treatment of it a certain arbitrary discretion. They by no means conceived themselves bound to adhere to the common interpretation or to imitate in story as in title their rivals and predecessors. Such a system would have amounted to a resignation of those claims to preference over their competitors which incited the composition. The Agamemnon story was exhibited on the Athenian theatre with as many variations as dramas.

I have presumed to employ a similar license.... Had I framed my story on this model, I should have done no more than have attempted to restore the lost drama of Æschylus; an ambition which, if my preference to this mode of treating the subject had incited me to cherish, the recollection of the high comparison such an attempt would challenge might well abate.[16]

For Shelley, like Lipchitz, myths such as Prometheus offered a point of departure. They posed characters and situations, but the conclusions were open to interpretation and reimagination. Prometheus may have been particularly ripe for this process because the story deals fundamentally with themes of creation.

The myriad invocations of Prometheus illuminate a rich, multilayered myth that has been engaged to varying ends and purposes. In each instance, aspects of the story have been culled or referenced to advance ideas that, when examined as a group, appear contradictory. At the broadest level, Prometheus has been cast and interpreted variously as heroic and tragic, Christlike and Satanic. Joseph Campbell, among others, perceived Christological associations in Prometheus's sacrifice and suffering.[17] Shelley saw Prometheus's theft of fire as comparable to Satan's transgressions. In more recent times, Prometheus has appeared as both villain and

Fig. 50. Constantin Brancusi (French, born Romania; 1876–1957). *Prometheus*, 1911. White marble, 5⅜ × 7 × 5⅜ inches (13.7 × 17.8 × 13.7 cm). Philadelphia Museum of Art. The Louise and Walter Arensberg Collection, 1950-134-5

hero in comic books produced by the genre's two leading English-language publishers: In DC Comics, Prometheus can be counted among the long list of Batman's archenemies; in Marvel Comics, the name was given to two separate minor characters, both of whom were heroes.

Such contradictions are nothing new. Reading Hesiod, Aeschylus, and Lucian offers three widely divergent takes on Prometheus. Franz Kafka's short story "Prometheus" centers on this very issue. Kafka briefly tells four differing tales of the Titan before concluding: "The legend tried to explain the inexplicable. As it came out of a substratum of truth it had in turn to end in the inexplicable."[18] Alternatively, the character and narrative are open to divergent constructions. Each incarnation of the subject is comprehensible. It is only when trying to take stock of all the invocations that the situation becomes muddled. This openness is also applicable to contemporary concerns. When the American artist and educator Tim Rollins selected Aeschylus's *Prometheus Bound* as a topic for a collaborative work with his group K.O.S. (Kids of Survival), he said that he wanted to explore the play because of "the currency and topicality of key issues" such as power, creativity, and the potential of creative power to be destructive.[19] Indeed, nearly every generation has identified relevant themes in the myth, though they have often disagreed about how to interpret those themes.

Fig. 51. Jacques Lipchitz (American, born Lithuania; 1891–1973). *Prometheus Strangling the Vulture*, begun 1943, cast 1952–53. Bronze, height 96½ inches (245.1 cm). Philadelphia Museum of Art. Purchased with the Lisa Norris Elkins Fund, 1952-8-1

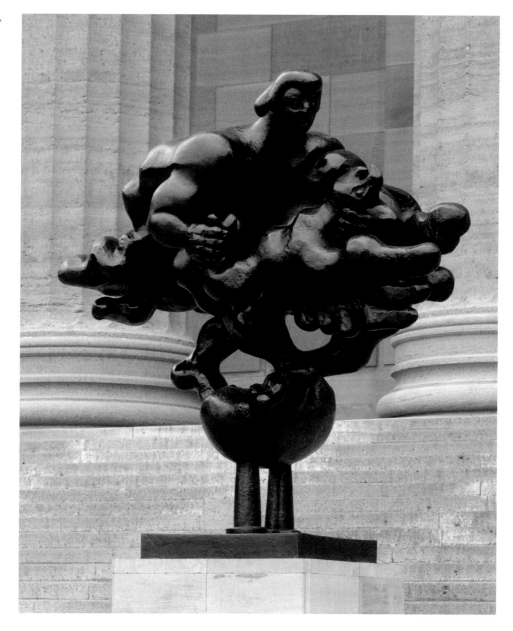

When Peter Paul Rubens set out to paint Prometheus, he was offering his own take on the mythical hero, but his painting nonetheless explores many of the modern ideas that others have engaged through the subject. Rubens presents us with a troubled creator who endures the most horrible of punishments for stealing the fire he needed to animate his creation. The conflation of narrative moments to include both the eagle's torture and the lit torch calls to mind the reason for Zeus's harsh punishment. As the bearer of the original Olympic flame, Rubens's figure is also open to being read as an icon of progress. In his depiction of the mythical source of all human creativity, Rubens has revealed to us his own search for inspiration, which took him through the art of antiquity to that of Michelangelo, Titian, and the artist's own Dutch and Flemish contemporaries. In turn, his *Prometheus Bound* inspired succeeding artists near and far, passing the torch of creativity forward.

NOTES

NOTES TO CHAPTER 1

1. Peter Paul Rubens to Sir Dudley Carleton, April 28, 1618. *The Letters of Peter Paul Rubens*, ed. and trans. Ruth Saunders Magurn (Cambridge, MA: Harvard University Press, 1955), p. 60.

2. Studies dedicated to *Prometheus Bound* include Julius S. Held, "Prometheus Bound," *Philadelphia Museum of Art Bulletin* 59, no. 279 (Autumn 1963), pp. 17–32; Charles Dempsey, "Euanthes Redivivus: Rubens's *Prometheus Bound*," *Journal of the Warburg and Courtauld Institutes* 30 (1967), pp. 420–25. In-depth discussions of the painting can also be found in Peter C. Sutton, *Northern European Paintings in the Philadelphia Museum of Art* (Philadelphia: Philadelphia Museum of Art, 1990), pp. 254–61; Aneta Georgievska-Shine, *Rubens and the Archaeology of Myth, 1610–1620: Visual and Poetic Memory* (Farnham, UK: Ashgate, 2009), pp. 35–42.

3. The oldest telling of the story of Prometheus is found in Hesiod's *Theogony*, from the late eighth century BCE. Hesiod also wrote about Prometheus in *Works and Days*. Prometheus features in several of Aesop's *Fables*, composed in the sixth century BCE. In the fifth century BCE Aeschylus penned a dramatic trilogy chronicling the Titan: *Prometheus Bound*, *Prometheus Unbound*, and *Prometheus the Fire-Bringer*. Also from the fifth century, Plato's dialogue *Protagoras* revolves in large part around the tale of Prometheus. Among the Roman writers, Ovid recounted the story of Prometheus in book 1 of his *Metamorphoses*. Numerous other ancient authors, including Hyginus, Lucian, Phaedrus, Cicero, Plutarch, and Valerius Flaccus, contributed to the long list of texts about Prometheus.

4. See Francis Bacon, "Prometheus, or the State of Man," in *De sapientia veterum* (1609).

5. Anton Pigler, *Barockthemen: Eine Auswahl von Verzeichnissen zur Ikonographie des 17. und 18. Jahrhunderts* (Budapest: Akadémiai Kiadó, 1974), vol. 2, pp. 222–25.

6. "Venise fut son idole pour le Coloris, et Rome poir la Correction du dessin." Jean François Michel, *Histoire de la vie de PP Rubens, Chevalier et Seigneir de Steen: Illustrée d' anecdotes qui n'ont jamais paru au public et de ses tableaux étalés dans le spalais, églises et places publiques d'Europe* (Brussels: De Bel, 1771), p. 35.

7. For a survey of eighteenth-century discussions of Rubens's combination of stylistic models, see Jeremy Wood, "Rubens as Thief: His Use of Past Art and Some Adaptations from Primaticcio," in *Concept, Design and Execution in Flemish Painting (1500–1700)*, ed. Hans Vlieghe, Arnout Balis, and Carl van de Velde (Turnhout, Belgium: Brepols, 2000), pp. 153–54.

8. Quoted in Larry L. Ligo, "Two Seventeenth-Century Poems Which Link Rubens' Equestrian Portrait of Philip IV to Titian's Equestrian Portrait of Charles V," *Gazette des beaux arts* 75 (1970), p. 351.

9. For a useful summary of early responses to Rubens's work, see Wood, "Rubens as Thief."

10. David Freedberg, "Rubens and Titian: Art and Politics," in *Titian and Rubens: Power, Politics, and Style*, ed. Hilliard T. Goldfarb, exh. cat. (Boston: Isabella Stewart Gardner Museum, 1998), pp. 29–68.

11. Most prominently among the Habsburgs, Titian made twenty-five paintings for Charles's son, King Philip II of Spain. See Charles Hope, "Titian and His Patrons," in *Titian: Prince of Painters*, ed. Susanna Biadene, exh. cat. (Venice: Palazzo Ducale; Washington, DC: National Gallery of Art, 1990), pp. 77–84.

12. See Giorgio Vasari, *The Lives of the Painters, Sculptors, and Architects*, trans. Gaston du C. de Vere (New York: Alfred A. Knopf, 1996), vol. 2, p. 793.

13. For example, Rubens's *Rape of Europa* (Museo Nacional del Prado, Madrid) closely copies Titian's painting of the same subject (Isabella Stewart Gardner Museum, Boston).

14. David Rosand, *The Meaning of the Mark: Leonardo and Titian*, The Franklin D. Murphy Lectures 8 (Lawrence, KS: Spencer Museum of Art, 1988), pp. 49–59.

15. Vasari, *Lives*, vol. 2, p. 794.

16. Karel van Mander, *Den grondt der edel vry schilder-const*, trans. Hessel Miedema (Utrecht: Haentjens Dekker and Gunbert, 1973), vol. 1, pp. 259–61.

17. Indeed, thanks to the great popularity that Titian enjoyed in the late sixteenth and early seventeenth centuries, his paintings could be found all over Europe, especially in royal and aristocratic collections.

18. David Jaffé, Elizabeth McGrath, and Minna Moore Ede, *Rubens: A Master in the Making*, exh. cat. (London: National Gallery, 2005), p. 14.

19. Rubens had another opportunity to study prime examples from the great Venetian painter when he returned to Spain in 1628. When he went to London in 1629–30, he encountered the art collection of King Charles I of England, which trailed only that in Madrid in quantity and quality of Venetian painting, including master works by Titian.

20. Vasari, *Lives*, vol. 2, pp. 793–94.

21. See, for example, Held, "Prometheus Bound," pp. 17–32; Sutton, *Northern European Paintings*, pp. 254–61.

22. Michelangelo's drawing may have been a source for Titian's painting as well. For a recent discussion of the relation, see Miguel Falomir, *Las Furias: Alegoría política y desafío artístico*, exh. cat. (Madrid: Museo Nacional del Prado, 2014), pp. 37–41. For the connections between the two artists more generally, see Paul Joannides, "Titian and Michelangelo / Michelangelo and Titian," in *The Cambridge Companion to Titian*, ed. Patricia Meilman (Cambridge: Cambridge University Press, 2011), pp. 121–45.

23. Blaise Ducos recently explored Rubens's interest in anatomy through the artist's engagement with *écorché* figures, which are modestly proportioned. Blaise Ducos, "Les corps les uns contre autres Rubens et la question de l'anatomie: Michel-Ange, De Vries, Petel," in *L'Europe de Rubens*, ed. Blaise Ducos, exh. cat. (Paris: Hazan; Lens: Musée du Louvre-Lens, 2013), pp. 215–84.

24. Jaffé has suggested that Rubens was inspired by the muscular slaves who rowed galleys in Italy and were known for their imposing physiques. Jaffé, McGrath, and Ede, *Rubens: A Master in the Making*, p. 26n6.

25. Will Fisher, "The Renaissance Beard: Masculinity in Early Modern England," *Renaissance Quarterly* 54, no. 1 (Spring 2001), pp. 155–87; Elliot Horowitz, "The New World and the Changing Face of Europe," *Sixteenth Century Journal* 28, no. 4 (1997), pp. 1181–1201.

26. Vasari, *Lives*, vol. 2, p. 737.

27. The other presentation drawings to Cavalieri include *The Dream* (Courtauld Gallery, London), *The Archers* (Royal Library, Windsor Castle), *Ganymede* (Harvard University Art Museums, Cambridge, MA), *Phaeton* (British Museum, London), and *Bacchanal* (Royal Library, Windsor Castle).

28. The known provenance of the drawing is as follows: to Tommaso de' Cavalieri (c. 1512–1587); Emilio de' Cavalieri (c. 1550–1602), from 1587; Cardinal Odoardo Farnese (1573–1626), by 1602; King George III (r. 1760–1820). See L. Sickel, "Die Sammlung des Tommaso de Cavalieri und die Provenienz der Zeichnungen Michelangelos," *Roemisches Jahrbuch der Bibliotheca Hertziana* 37 (2006), pp. 163–221, especially pp. 170–81.

29. John Rupert Martin, *The Farnese Gallery* (Princeton: Princeton University Press, 1965), pp. 153–56; Michael Jaffé, "The Interest of Rubens in Annibale and Agostino Carracci: Further Notes," *Burlington Magazine* 99, no. 656 (November 1957), pp. 374–77.

30. Jeffrey Muller, "Rubens's Collection in History," in *A House of Art: Rubens as Collector*, ed. Kristin Lohse Belkin and Fiona Healy (Antwerp: Rubenshuis and the Rubenianum, 2004), p. 65.

31. Michael Jaffé, "Rubens as a Collector of Drawings," *Master Drawings* 2, no. 4 (Winter 1964), pp. 383–97, especially pp. 385–86. Clovio's drawing is now in the Royal Library, Windsor Castle.

32. Michael Hirst, *Michelangelo: Draftsman*, exh. cat. (Washington, DC: National Gallery of Art, 1988), p. 14. The remainder of the inscription is illegible.

33. Jeremy Wood, *Rubens: Copies and Adaptations from Renaissance and Later Artists: Italian Artists III, Artists Working in Central Italy and France*, Corpus Rubenianum Ludwig Burchard 26.2.3 (London: Harvey Miller; Turnhout, Belgium: Brepols, 2011), vol. 2, no. 88. The drawing is now in the Musée du Louvre, Paris.

34. Vasari, *Lives*, vol. 1, p. 645.

35. Ibid., p. 666.

36. Maurice Poirier, "The Disegno-Colore Controversy Reconsidered," *Explorations in Renaissance Culture* 13 (1987), pp. 52–86.

37. The exceptions are his two copies of Michelangelo's *Leda and the Swan* (now lost), which Rubens executed in paint around 1598–1602 (Fogg Art Museum, Cambridge, MA; Gemäldegalerie Alte Meister, Dresden).

38. At least three sheets by Rubens's pupils after Michelangelo's *Moses* (Statens Museum for Kunst, Copenhagen) and *Battle of the Lapiths and Centaurs* (Collection Frits Lugt, Paris; Museum Boijmans van Beuningen, Rotterdam) suggest that Rubens may have been inspired by

these sculptures to lay pen or chalk to paper, but these are exceptions even among his pupils' work. Wood, *Rubens: Copies and Adaptations*, vol. 2, no. 81.

39. Ibid., vol. 1, pp. 129–96.

40. See, for example, H. W. van Helsdingen, "The Laocoön in the Seventeenth Century," *Simiolus: Netherlands Quarterly for the History of Art* 10, nos. 3/4 (1978–79), pp. 127–41.

41. Pliny the Elder, *Natural History* 36.4.37–38.

42. See Falomir, *Las Furias*, pp. 165–66.

43. Falomir argues that Titian was even more faithful to the Laocoön than Michelangelo was. Ibid.

44. See, for example, John R. Martin, *Rubens: The Antwerp Altarpieces* (New York: W. W. Norton, 1969), pp. 48–49.

45. Before restorations to the sculpture performed in the late 1950s, Laocoön's arm appeared raised and straight rather than bent behind his head. This was in part due to the fact that the sculpture was rediscovered unassembled and that some parts, like the arm, required refurbishment. Rubens's drawing and old plaster casts such as that in the Pennsylvania Academy of Fine Arts illustrate the earlier composition. For the restoration, see Filippo Magi, *Il riristino del Laocoönte*, Atti della Pontifica Accademia Romana di Archeologia, Memorie, ser. 3, vol. 9, no. 1 (Vatican City: Tipografia poliglotta vaticana, 1960).

46. Coxcie's painting may be based on the "Dead Giant" antique marble in the Museo Archeologico Nazionale, Naples (inv. 6013), which was in the Farnese collection in the sixteenth and seventeenth centuries. See Christina Riebesell, *Die Sammlung des Kardinal Alessandro Farnese: Ein 'Studio' für Künstler und Gelehrte* (Weinheim, Germany: VCH, Acta Humaniora, 1989), pp. 50–51.

47. For the attribution of the drawing, see Kristin Lohse Belkin, *Rubens: Copies and Adaptations from Renaissance and Later Artists: German and Netherlandish Artists*, Corpus Rubenianum Ludwig Burchard 26.1 (London: Harvey Miller; Turnhout, Belgium: Brepols, 2009), nos. 112, 113.

48. Fiona Healy, "Male Nudity in Netherlandish Painting of the Sixteenth- and Early Seventeenth-Centuries," in *The Nude and the Norm in the Early Modern Low Countries*, ed. Karolien de Clippel, Katharina Van Cauteren, and Katlijne van der Stighelen (Turnhout, Belgium: Brepols, 2011), pp. 131–58. See also Belkin, *Rubens: Copies and Adaptations*, nos. 112, 113.

49. Vasari, *Lives*, vol. 2, pp. 862, 864.

50. Ibid.

51. Koenraad Jonckheere and Ruben Suykerbuyj, "The Life and Times of Michiel Coxcie, 1499–1592," in *Michiel Coxcie and the Giants of His Age*, ed. Koenraad Jonckheere, exh. cat. (London: Harvey Miller, 2013), p. 45.

52. Karl Johns notes that Coxcie would have been a worthy model for Rubens's emulation. Karl Johns, "Peter Paul Rubens, Michiel Coxcie und der Antwerpener Strumpfwirker-Altar," in *Die Malerei Antwerpens: Gattungen, Meister, Wirkungen; Studien zur flämischen Kunst des 16. und 17. Jahrhunderts*, ed. Ekkehard Mai et al. (Cologne: Locher, 1994), pp. 18–27.

53. Van Mander identified Van Orley as Coxcie's teacher, but no corroborating evidence has been uncovered. Karel van Mander, *The Lives of the Illustrious Netherlandish and German Painters, from the First Edition of the Schilder-boek*, trans. Hessel Miedema (Doornspijk, Netherlands: Davaco, 1994), vol. 1, pp. 280–81.

54. Van Orley's visualization is indebted to Raphael's *Expulsion of Heliodorous from the Temple* (Vatican Palace) and Luca Signorelli's *Signs of the Last Days* (Cappella Nuova, Orvieto, Italy).

55. Alexandre Galand, *The Flemish Primitives: Catalogue of Early Netherlandish Painting in the Royal Museums of Fine Arts of Belgium*, vol. 6, *The Bernard van Orley Group* (Turnhout, Belgium: Brepols, 2013), pp. 199–200.

56. Only the central panel of the altarpiece survives (Koninklijk Museum voor Schone Kunsten, Antwerp). Van Mander discusses the *Fall of the Rebel Angels* in the *Schilderboek*. Van Mander, *Lives of the Illustrious Netherlandish and German Painters*, vol. 1, p. 241r.

57. It is not clear what painting, if any, served as a source for the print. Van de Velde linked it to the Labors of Hercules series and lost paintings from 1554–55 for Nicolaas Jonghelinck. See Carl van de Velde, *Frans Floris: Leven en Werken* (Brussels: Paleis der Academiën, 1975), p. 407.

58. J. P. Guépin, "Hercules belegerd door de Pygmeeën, schilderijen van Jan van Scorel en Frans Floris naar een Icon van Philostratus," *Oud Holland* 102, no. 2 (1988), pp. 155–73. An *ekphrasis* is a written description of a work of art, real or imagined.

59. Vasari mentioned prints by Cort after Floris, including *Hercules and the Pygmies* and *Cain and Abel*, but misattributed them to their publisher, Hieronymus Cock. Vasari, *Lives*, vol. 2, p. 100.

60. Van Mander, *Lives of the Illustrious Netherlandish and German Painters*, p. 293r. Van Mander misidentified the subject as the Brazen Serpent. Pieter van Thiel connected Van Mander's description to the London painting. Pieter

J. J. van Thiel, *Cornelis Cornelisz van Haarlem, 1562–1638: A Monograph and Catalogue Raisonné* (Doornspijk, Netherlands: Davaco, 1999), p. 341.

61. Cornelis and Goltzius produced several works that, while less directly Michelangelesque, explored complicated figural poses, especially of falling male nudes. Cornelis's magisterial *Fall of the Rebel Angels* of 1588–90 (Statens Museum for Kunst, Copenhagen) presents a spectacle of seemingly infinitely arrayed tumbling male bodies. This painting derives from Floris's 1554 treatment of the same theme (Koninklijk Museum voor Schone Kunsten, Antwerp), illustrating Floris's own impact and currency for succeeding generations of artists in northern Europe.

62. Of the three, only *Sisyphus* (Museo Nacional del Prado, Madrid) survives.

63. Lawrence W. Nichols, *The Paintings of Hendrick Goltzius* (Doornspijk, Netherlands: Davaco, 2013), p. 60.

64. Ibid.

65. Filip Vermeylen and Karolien de Clippel, "Rubens and Goltzius in Dialogue: Artistic Exchanges between Antwerp and Haarlem during the Dutch Revolt," *De Zeventiende Eeuw* 28, no. 2 (2012), pp. 138–60.

66. See J. G. van Gelder, "Rubens in Holland in de zeventiende eeuw," *Nederlands kunsthistorisch jaarboek / Netherlands Yearbook for History of Art* 3 (1950–51), pp. 119–20; R. De Smet, "Een nauwkeurige datering van Rubens' eerste reis naar Holland in 1612," *Jaarboek Koninklijk Museum voor Schone Kunsten Antwerpen* (1977), pp. 199–220.

67. Rubens owned and annotated a copy of Vasari's *Lives*. Unfortunately, Rubens's copy disappeared from Holker Hall in England sometime before World War II. See Prosper Arents, *De bibliotheek van Pieter Pauwel Rubens: Een reconstructie* (Antwerp: Vereniging der Antwerpse Bibilofielen, 2001), pp. 94–98.

68. Quintilian, as quoted in Muller, "Rubens's Collection in History," p. 231.

69. Ibid., p. 234.

70. Donald Posner, *Annibale Carracci: A Study in the Reform of Painting around 1590* (London: Phaidon, 1971), vol. 1, pp. 87–88. Later writers, from Gian Pietro Bellori (1672) and Carlo Cesare Malvasia (1678) to Roger de Piles (1699), testified to Annibale's assimilative powers. See Maria H. Loh, "New and Improved: Repetition as Originality in Italian Baroque Practice and Theory," *Art Bulletin* 86, no. 3 (September 2004), p. 485. Later in the century, Malvasia would write that to become a good painter one must acquire "Roman *disegno*, the movement and shadowing of the Venetians, and the dignified colors of Lombardy," and also take "from Michelangelo the awesome way, the true and natural from Titian, the pure refined style from Correggio, decorum and structure from Tibaldi, invention from the wise Primaticcio, and a bit of grace from Parmigianino." Malvasia quoted and translated in ibid., pp. 487–88.

71. Loh characterized this process as *misto* (mixture) and argued that mixture of styles was a desired artistic project. See ibid., pp. 422–79. While Loh concentrates on Italian aesthetics, related positions can also be found in northern European texts. Van Mander, for example, wrote, "Steel hebzuchtig armen, benen, rompen, handen, voeten / Het is hier niet verboden wie willen die / moeten el de rol van Rapiamus spelen / Goed gekookte rapen is geode soep" [Steal arms legs torsos hands and feet / Tis not forbidden here: those who will / Must play Rapiamus's personage / Well-cooked rape makes good pottage]. Van Mander, *Den grondt*, p. 86. Van Mander makes a pun on *rapen*—turnips in Dutch, but also connected to the word for rape.

72. Rubens to Annibale Chiepio, December 2, 1606, in Rubens, *Letters*, p. 39.

NOTES TO CHAPTER 2

1. James Clifton, "The Face of a Fiend: Convulsion, Inversion, and the Horror of the Disempowered Body," *Oxford Art Journal* 34, no. 3 (2011), pp. 373–92.

2. "Heic rostro adunco vulture immanis fodit / Jecur Promethei, nec datur quies mails, / Sic usque et usque radbidus ales imminent / Faecunda poenis appentens praecordia. / Non est co contentus infandae dapis / Pastu, sed ungue laniat insuperfero / Hinc ora palpitantis, hinc femur viri. / Ipse involaret in necem spectantium / Ni vincla tardent; quod potest unum tamen / Flammata torquens huc et illuc lumina, / Terret timentes; pectore ebullit cruor. / Et parte ab omni qua pedes signant notam. / Trucesque flammas vibrat acies luminum / Rapidae volucris, hanc moveri; hanc tu putes / Quassare pennas; horror adstantes habet." Composed in 1612, the poem was published posthumously in Dominicus Baudius, *Poematum nova editio* (Leiden, 1616). English translation from Charles Dempsey, "Euanthes Redivivus: Rubens's *Prometheus Bound*," *Journal of the Warburg and Courtauld Institutes* 30 (1967), p. 421.

3. David Summers, "Terribilità," in *Michelangelo and the*

Language of Art (Princeton: Princeton University Press, 1981), pp. 234–41.

4. Giorgio Vasari, *The Lives of the Painters, Sculptors, and Architects*, trans. Gaston du C. de Vere (New York: Alfred A. Knopf, 1996), vol. 1, p. 687.

5. For discussion of the effect of the scale of Michelangelo's work, see Thomas Puttfarken, "Michelangelo and Titian: Terribilità and Tragic Pathos," in *Titian and Tragic Painting: Aristotle's Poetics and the Rise of the Modern Artist* (New Haven: Yale University Press, 2005), p. 111.

6. Ibid.

7. Margarete Bieber, *Laocoön: The Influence of the Group since Its Rediscovery*, 2nd ed. (Detroit: Wayne State University Press, 1967), pp. 12–16; Maria H. Loh, "Outscreaming the Laocoön: Sensation, Special Affects, and the Moving Image," *Oxford Art Journal* 34, no. 3 (2011), pp. 393–414.

8. Jacopo Sadoleto, "De Laocoontis statua" (1506), as translated in Bieber, *Laocoön*, pp. 13–15.

9. Ibid., p. 14.

10. Loh, "Outscreaming the Laocoön," pp. 398–402.

11. L. D. Ettlinger, "Exemplum Doloris: Reflections on the Laocoön Group," in *Essays in Honor of Erwin Panofsky*, ed. Millard Meis (New York: New York University Press, 1961), vol. 1, pp. 121–26; A. Warburg, "A Lecture on Serpent Ritual," *Journal of the Warburg Institute* 2, no. 4 (April 1939), pp. 289–92. For an engaging analysis of Warburg's examination of the Laocoön, see Richard Brilliant, *My Laocoön: Alternative Claims in the Interpretation of Artworks* (Berkeley: University of California Press, 2000), pp. 35–38.

12. Giovanni Paolo Lomazzo, *Trattato dell'arte della pittura, scoltura et architettura* (Milan, 1585), as translated in Dempsey, "Euanthes Redivivus," p. 424.

13. Dempsey believed that Rubens was inspired directly by Achilles Tatius's *ekphrases*, but he also could have derived enough inspiration from Lomazzo's second-hand description. Ibid.

14. Olga Raggio, "The Myth of Prometheus: Its Survival and Metamorphosis up to the Eighteenth Century," *Journal of the Warburg and Courtauld Institutes* 21 (1958), p. 62.

15. Anne Woollett considered how Rubens's *Head of Medusa* from about 1617–18 (Kunsthistorisches Museum, Vienna) displays the aesthetic of *terribilità*. Anne Woollett and Ariane van Suchtelen, eds., *Rubens and Brueghel: A Working Friendship*, exh. cat. (Los Angeles: J. Paul Getty Museum; The Hague: Royal Picture Gallery Mauritshuis, 2006), p. 182.

16. The sculpture was long thought to portray Seneca, until the discovery in the early nineteenth century of a labeled portrait herm (now in the Antikensammlung of the Pergamonmuseum, Berlin). See Wolfram Prinz, "*The Four Philosophers* by Rubens and the Pseudo-Seneca in Seventeenth-Century Painting," *Art Bulletin* 55, no. 3 (September 1973), pp. 410–28. I thank Michele Frederick for sharing this citation.

17. Among other works, Lipsius published *Annaei Senecae philosophi Opera* (Antwerp: Plantijn-Moretus, 1605), an influential commentary on Seneca that was widely read throughout Europe.

18. *Justus Lipsius' Concerning Constancy*, ed. and trans. R. V. Young (Tempe: Arizona Center for Medieval and Renaissance Studies, 2011), pp. 27–29.

19. "The Neostoicism of Lipsius was the first systematic revival of Roman Stoicism since antiquity. In the troubled times of the religious wars and the struggles of the Netherlands, his philosophy provided comfort for individuals faced with disruption of their lives, loss of their liberty, and death, and his political and military doctrines were studied and followed by leaders of both sides of the struggles." Mark Morford, *Stoics and Neostoics: Rubens and the Circle of Lipsius* (Princeton: Princeton University Press, 1991), p. xiii.

20. See W. Brassat, "Tragik, versteckte Kompositionskunst und Katharsis," in *Rubens Passioni: Kultur der Leidenschaften im Barock*, ed. Ulrich Heinen and Andreas Thielemann (Göttingen, Germany: Vandenhoeck und Ruprecht, 2001), pp. 41–63.

21. See Mieke B. Smits-Veldt, *Het Nederlandse renaissancetoneel* (Utrecht: HES, 1991), pp. 45–55; Eric Jan Sluijter, "How Rembrandt Surpassed Ancients, Italians and Rubens as the Master of 'the Passions of the Soul,'" *Low Countries Historical Review* 129, no. 2 (2014), p. 79.

22. See Cicero, *Tusculanae disputationes* 2.10 (written around 45 BCE); see also Raggio, "Myth of Prometheus," p. 50.

23. *Justus Lipsius' Concerning Constancy*, pp. 26–28. Lipsius identified himself with Prometheus and compared his own suffering to that endured by the Titan. Rubens's brother Philip also referred to Lipsius, his former teacher, as Prometheus in a poem written in 1602 and published in 1615. See Philip Rubens, "A Song of Gratitude, Offered to Justus Lipsius, His Teacher and Friend," translated in Frances Huemer, *Rubens and the Roman Circle: Studies of the First Decade* (New York: Garland, 1996), p. 158.

24. Huemer, *Rubens and the Roman Circle*, p. 74.

25. Morford, *Stoics and Neostoics*, p. 186.

26. Lipsius also advocated reason, freedom from emotions, patience in adversity, and cheerful submission to God. Ibid., p. 162.

27. As noted in chapter 1, Michelangelo experimented with reorienting the pose of his *Tityus* into that of the Resurrected Christ on the reverse of the Windsor Castle drawing (see plate 3b).

28. In a related fashion, in the engraving *Prometheus Creating Man* (c. 1589) Goltzius depicted Prometheus animating the first human by placing the torch directly below the left pectoral.

29. Percy Shelley may have been the first to make the connection explicit; see the coda to this book.

30. As Ettlinger pointed out, sixteenth-century theologians suggested that artists study the Laocoön when creating images of the Passion of Christ and the suffering of saints and martyrs. See, for example, Giovanni Andrea Gilio, *Due dialoghi* (1564), p. 87; Antonio Possevino, *Biblioteca selecta* (Rome, 1593), p. 317; Ettlinger, "Exemplum Doloris," p. 126.

31. Raggio, "Myth of Prometheus," pp. 44–62. Among those who discussed Prometheus were Tertullian, Bishop of Carthage, in the first century CE; Petrus Comestor, in his widely read *Historia scholastica* of 1178; the anonymous authors of the *Ovide moralisé* of the early fourteenth century; Marsilio Ficino, in *Quaestiones quinque de mente* of 1476–77; Giovanni Boccaccio, in *Genealogiae* of 1494; Charles de Bouelles, in *Liber de sapiente* of 1509; and Desiderius Erasmus, in *Letter 116*, penned in 1518.

32. John Abbott, *Iesus praefigured* (1623), pp. 91–95.

33. *The Spiritual Exercises of St. Ignatius*, ed. John F. Thornton, trans. Louis J. Puhl (New York: Vintage, 2000).

34. These paintings were destroyed by a fire in the church in 1718. See John Rupert Martin, *The Ceiling Paintings for the Jesuit Church in Antwerp*. Corpus Rubenianum Ludwig Burchard 1 (London: Harvey Miller, 1968).

NOTES TO CHAPTER 3

1. Aeschylus, *Prometheus Bound*, trans. James Scully and C. J. Herrington (New York: Oxford University Press, 1975), pp. 34–35.

2. Aneta Georgievska-Shine, *Rubens and the Archaeology of Myth, 1610–1620: Visual and Poetic Memory* (Farnham, UK: Ashgate, 2009), p. 37. Perhaps importantly, Rubens's brother Philip purchased a collection of the writings of Aeschylus in 1605. Rubens and his brother shared an apartment in Rome from 1604 to 1606. As a result, the painter must have been introduced to Aeschylus and his interpretation of the Prometheus story.

3. See Olga Raggio, "The Myth of Prometheus: Its Survival and Metamorphosis up to the Eighteenth Century," *Journal of the Warburg and Courtauld Institutes* 21 (1958), p. 46.

4. A number of surviving Attic vases illustrate scenes from the life of the Titan. Likewise, some editions of Ovid bear illustrations of Prometheus. For a survey of the visual and literary figurations of Prometheus, see ibid., pp. 44–62.

5. Anton Pigler found that it was extremely rare for Prometheus to be depicted in the act of stealing the fire from the heavens. See Anton Pigler, *Barockthemen: Eine Auswahl von Verzeichnissen zur Ikonographie des 17. und 18. Jahrhunderts* (Budapest: Akadémiai Kiadó, 1974), vol. 2, pp. 222–25. Rubens himself painted Prometheus stealing the fire in an oil sketch that dates to around 1630. See Matías Díaz Padrón, *El siglo de Rubens en el Museo del Prado: Cátalogo razonado de pintura flamenca del siglo XVII* (Madrid: Museo del Prado, 1995), vol. 2, pp. 1034–35.

6. Dominicus Baudius, *Poematum nova editio* (Leiden, 1616).

7. Peter Sutton, "'Tutti finite con amore': Rubens' 'Prometheus Bound,'" in *Essays in Northern European Art Presented to Egbert Haverkamp-Begemann on His Sixtieth Birthday*, ed. Anne-Marie Logan (Doornspijk, Netherlands: Davaco, 1983), pp. 270–76; quote on p. 274.

8. Ibid., p. 275.

9. Georgievska-Shine, *Rubens and the Archaeology of Myth*, pp. 35–42.

10. Ibid., p. 41.

11. "Prouit en praeceps gaviori turbine, quisquis / Magna petit: veluti culmina summa cadunt. / Tutius ut graditur, modica qui sorte beatus / Æqualem Vite gaudet adess Viam." Translation from Ilja M. Veldman, *Maarten van Heemskerck and Dutch Humanism in the Sixteenth Century*, trans. Michael Hoyle (Maarssen, Netherlands: G. Schwartz, 1977), p. 80.

12. Miguel Falomir, *Las Furias: Alegoría política y desafío artístico*, exh. cat. (Madrid: Museo Nacional del Prado, 2014), p. 177.

13. Ibid.; Pieter J. J. van Thiel, "Cornelis van Haarlem, Tityus, 1588," in *Dawn of the Golden Age: Northern Netherlandish Art, 1580–1620*, ed. Ger Luijten, exh. cat. (Amsterdam: Rijksmuseum, 1993), pp. 333–34.

14. Karel van Mander, *Den grondt der edel vry schilder-const*,

ed. and trans. Hessel Miedema (Utrecht: Haentjens Dekker and Gumbert, 1973), vol. 1., p. 137.

15. Ibid., vol. 1., p. 157.

16. Prosper Arents, *De bibliotheek van Pieter Pauwel Rubens: Een reconstructie* (Antwerp: Verening der Antwerpse Bibliofielen, 2001), pp. 94–98.

17. See Beverly Louise Brown, "From Hell to Paradise: Landscape and Figure in Early Sixteenth-Century Venice," in *Renaissance Venice and the North: Crosscurrents in the Time of Bellini, Dürer, and Titian*, ed. Bernard Aikema and Beverly Louise Brown, exh. cat. (New York: Rizzoli, 1999), pp. 424–31; Paul Hills, "Titian's Fire: Pyrotechnics and Representations in Sixteenth-Century Venice," *Oxford Art Journal* 30, no. 2 (2007), pp. 185–204.

18. Hills, "Titian's Fire," p. 185.

19. *The Letters of Peter Paul Rubens*, ed. and trans. Ruth Saunders Magurn (Cambridge, MA: Harvard University Press, 1955), p. 60.

20. Susan Koslow, *Frans Snyders: The Noble Estate; Seventeenth-Century Still-Life and Animal Painting in the Southern Netherlands* (Brussels: Fonds Mercator, 2006), p. 14.

21. Anne T. Woollett and Ariane van Suchtelen, eds., *Rubens and Brueghel: A Working Friendship*, exh. cat. (Los Angeles: J. Paul Getty Museum; The Hague: Royal Picture Gallery Mauritshuis, 2006), p. 11.

22. Giovanni Crivelli, *Giovanni Brueghel, pittor fiammingo, o sue lettere e quadretti esistenti presso l'Ambrosiana* (Milan: Ditta Boniardi-Pogliani di E. Besozzi, 1868), pp. 198–99.

23. Koslow, *Frans Snyders*, p. 16.

24. Snyders was dean of the group in 1628. Rubens had joined the Romanists in 1609 and served as dean in 1613.

25. Woollett and Van Suchtelen, *Rubens and Brueghel*, pp. 10–11.

26. The practice seems to have been highly localized, existing predominately in Antwerp. The earliest known example of such collaboration is that between Joachim Patinir and Quentin Massys, on *Temptation of St. Anthony* from about 1522 (Museo Nacional del Prado, Madrid). See Alejandro Vergara, ed., *Patinir: Essays and Critical Catalog* (Madrid: Museo Nacional del Prado, 2007), pp. 242–53.

27. Elizabeth Alice Honig, *Painting and the Market in Early Modern Antwerp* (New Haven: Yale University Press, 1998), p. 177.

28. Ibid. For a number of Snyders's contemporaries, the percentage of collaborative works is even higher: 41 per-
cent for Jan Brueghel the Elder, 50 percent for Jan Brueghel the Younger, 40 percent for Daniel Seghers, and 60 percent for Joos de Momper the Younger.

29. "Todas son de su mano y de Esneyre, del uno las figuras y paises y del otro los animales." See Arnout Balis, *Rubens: Hunting Scenes*, Corpus Rubenianum Ludwig Burchard 18.2 (London: Harvey Miller, 1986), pp. 218–64; Svetlana Alpers, *The Decoration of the Torre de la Parada*, Corpus Rubenianum Ludwig Burchard 9 (New York: Phaidon; Brussels: Arcade, 1971), pp. 117–18.

30. Koslow, *Frans Snyders*, p. 306.

31. Dennis P. Weller, "Peter Paul Rubens and Frans Snyders: The Business of Collaboration," in *Rubens: Inspired by Italy and Established in Antwerp*, ed. Toshiharu Nakamura, exh. cat. (Tokyo: Bunkamura Museum of Art; Kitakyushu, Japan: Kitakyushu Municipal Museum of Art; Nagaoka, Japan: Niigata Prefectural Museum of Modern Art, 2013), pp. 246–47.

32. Honig, *Painting and the Market*, p. 188.

NOTES TO CHAPTER 4

1. *The Letters of Peter Paul Rubens*, ed. and trans. Ruth Saunders Magurn (Cambridge, MA: Harvard University Press, 1955), p. 60.

2. Karolien de Clippel, "Smashing Images: The Antwerp Nude between 1563 and 1585," in *Art after Iconoclasm: Painting in the Netherlands between 1566 and 1585*, ed. Koenraad Jonckheere and Ruben Suykerbuyk (Turnhout, Belgium: Brepols, 2012), pp. 66, 73; Charles Hope, "Problems of Interpretation in Titian's Erotic Paintings," in *Tiziano e Venezia: Atti del convegno internazionale di studi, Venezia, 1976*, ed. Massimo Gemin and Giannantonio Paladini (Vicenza, Italy: N. Pozza, 1980), p. 112.

3. Miguel Falomir, *Las Furias: Alegoría política y desafío artístico*, exh. cat. (Madrid: Museo Nacional del Prado, 2014), pp. 25–62.

4. Ibid., pp. 33–36.

5. Rubens mentions these patrons in his correspondence to Carleton. See *Letters*, p. 61.

6. Jeffrey Muller, "Rubens's Collection in History," in *A House of Art: Rubens as Collector*, ed. Kristin Lohse Belkin and Fiona Healey (Antwerp: Rubenshuis and Rubenianum, 2004), pp. 53–55.

7. Giovanni Pietro Bellori, *Le vite de' pittori, scultori et architetti moderni* (Rome, 1672), p. 247. As translated by Muller, "Rubens's Collection in History," p. 53.

8. As quoted and translated in ibid., p. 53 (no citation given).

PHOTOGRAPHY CREDITS